MASTERS OF ORIGAMI

AT HANGAR-7

The Art of Paperfolding

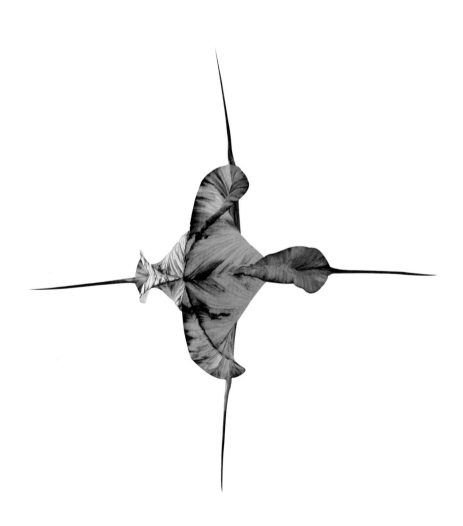

MASTERS OF ORIGAMI

AT HANGAR-7

Hatje Cantz

The Art of Paperfolding

Contents

Introduction

V'Ann Cornelius
Co-Curator

Origami is presently experiencing the most exciting, dynamic phase of its millennia-long history. Never before this era were more striking, creative, innovative origami pieces created. Never before did origami play a role in so many people's lives. Never before did origami exert such strong influence on scientists, mathematicians, educators, architects, designers all over the world.

Against this backdrop and within the fascinating setting of the Hangar-7 in Salzburg an exceptional exhibition concept was translated into reality. It is the first presentation of origami in all its diverse aspects, illustrated with outstanding pieces and outstanding artists: the "Masters of Origami."

80 "Masters of Origami" from 16 different countries have been invited to let themselves be inspired by the idea of this exhibition, the unique setting of the Hangar-7 and the pioneering spirit of our 'hosts,' the Flying Bulls. We were met with enthusiasm and a willingness to collaborate, all of which has let the "Masters of Origami" become a platform of the world's best folders.

This book also forms part of the exhibition, as its documentation but also as a work in its own right. It contains a representative selection of about 60 of the almost 200 pieces shown in the Hangar-7. And it enriches the experience at Hangar-7 with texts by some of the really great "Masters of Origami." David Lister has dedicated an homage to the deceased "godfather" Akira Yoshizawa, Koshiro Hatori has written about on the history of the art of folding paper, Michael LaFosse's contribution focuses on perfect paper, Robert Lang's on mathematical and scientific aspects of origami, while Paul Jackson has explored origami in art and design.

I had the pleasure of curating the exhibition "Origami Masterworks" at the Mingei International Museum in San Diego, California which opened in September 2003. The exhibition, originally scheduled for three months continued for more than 18 months. It triggered an origami rage in the United States, which no one had really expected. I was greatly honoured to be asked to co-curate the "Masters of Origami" exhibition at the Hangar-7 venue. It's our goal and conviction that the "Masters of Origami" – both as an exhibition and as this book – will continue to enhance the presence of origami and that even more people will be attracted by the mesmerizing power of the art of folding.

In closing, I would like to direct your attention to the fact that all of the proceeds from this book at the Hangar-7 will serve a charitable purpose. The Foundation "Wings for Life" is dedicated to the study of the central nervous system and has set itself the goal of making paraplegia curable. I am delighted and also proud that the "Masters of Origami" can support this important research.

Essays and Perspectives

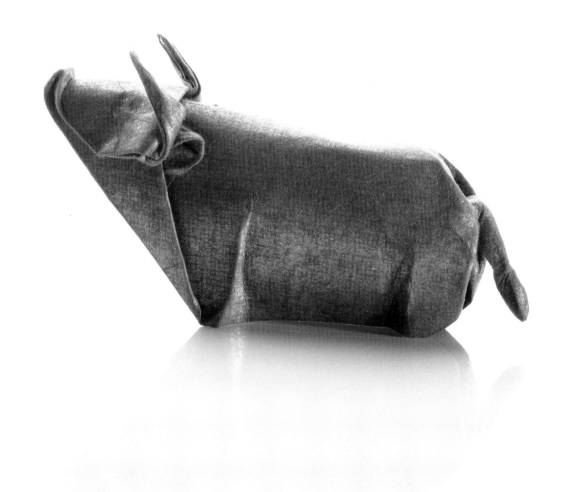

The Making of a Paperfolder:
Akira Yoshizawa

David Lister

(Page 9) **"Bull,"** created 1960

One of the twelve signs of the Japanese Zodiac.

"Gorilla," created 1963, folded 1974

The gorillas in the Tama and Ueno Zoos served as inspiration. The three animal sculptures were folded from thick, colored paper in the wet folding technique.

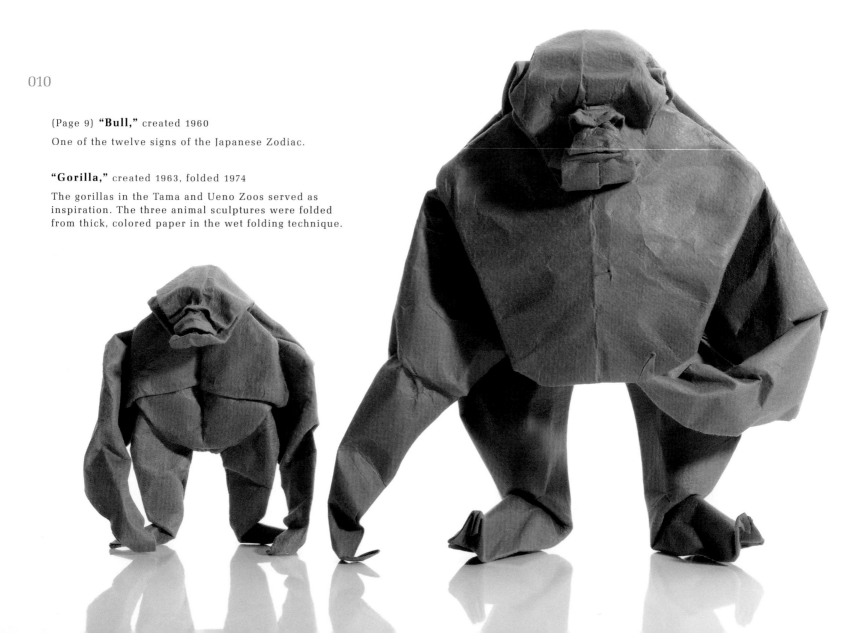

When Akira Yoshizawa died on 14 March, his 94th birthday, paperfolders all over the world not only mourned a dearly beloved colleague, but also celebrated the achievements of the greatest Origami artist who has ever lived.

Fifty years ago, Yoshizawa was already being described as "far and away the greatest folder in the world, devoted to this delicate and gentle art form to an extent which it is hardly possible to believe." Even then he was a living legend, and he was to remain so for the rest of his life.

Akira Yoshizawa was aged four when, after having received a paper boat and watching his older brothers pull it apart, he went about refolding his violated gift. As he grew older he learnt to fold the usual traditional folds familiar to children, although it was not until he was aged fifteen that he began to create new models for himself. But he came from a cultured family and was well-exposed to the visual arts and music, which in turn sharpened his artistic sensibilities.

Before Yoshizawa transformed Origami, there were in Japan, in addition to ceremonial paper folding, generally two kinds of recreational origami. One kind consisted of traditional children's models. All children knew a few traditional folds, and there was little tendency to invent new models for oneself: boys had their boats and gliders, and girls had their cranes and fortune tellers. These were usually simple models which were uncut and which had been passed down over the centuries with little change. Indeed, the Japanese generally regarded paperfolding as a children's pastime.

Nevertheless, there was also a different kind of paperfolding practised by adults. New designs were created, but they usually involved extensive cutting. The first evidence of this practice is from the 1797 book, "Sembazuru Orikata" (How to Fold 1000 Cranes). The best information about this cut kind of folding can be found in the Kayaragusa (often known as the "Kan no mado"). This is a unique, private manuscript encyclopaedia which dates from around 1845. A later renowned exponent of the cut style of folding was Michio Uchiyama, who continued to write books well into the 20th century.

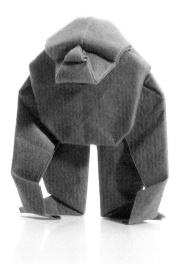

Yoshizawa turned away from this cut style of folding and went back to the general ideas of traditional folding, which he used as the basis for his "Sosaku Origami" or "Creative Paperfolding." With this approach he folded his own inventive models, models which employed new techniques with the greatest economy and elegance. Yoshizawa only very occasionally used cutting, such as for minor details like a shrimp's antennae. He employed the traditional fish, bird and frog bases and used

The Making of a Paperfolder:
Akira Yoshizawa

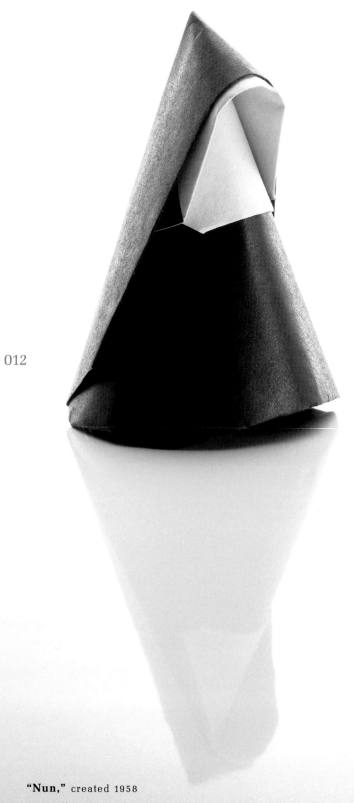

"Nun," created 1958

Specially prepared paper. Black and white
Japanese paper (kuromasa gami) laminated
together to form a single sheet

them in previously unheard-of ways. Yet much of his folding was of a direct kind that did not need bases, and he could use the most minimal techniques to create delightful flowers, leaves, birds and animals.

In order to fold proper animals with a head, tail and four legs, Yoshizawa frequently used two squares of paper, one for the front parts and another for the hind parts. Western folders were not keen on this device because they were of the opinion that folding should be done from a single square. Nevertheless, Yoshizawa continued to fold animals in this way, and this technique allowed him to fold the most realistic animals. The breeds of his dogs are instantly recognisable.

Later, newer methods of folding were discovered by Yoshizawa and other folders chiefly by folding the corners of the square to the centre and by treating this as the basic square. It is a technique that has, quite astonishingly, made it possible to fold the most complex insects and sea creatures – complete with all their appendages – from a single uncut square. Sometimes Yoshizawa himself used these methods. But he never sought complexity for its own sake, and he continued to fold wonderful models with deceptive simplicity of technique. His models are instantly recognisable as his own, they exude life, character and humour, and they fulfil his stipulation that the models should have a lifelike quality—from his ferocious, lowering gorilla to his chattering cocks and hens and their cheerful chicks. Perhaps his best-loved fold is his amazingly simple butterfly, delightfully elegant, which even went on to become his symbol.

Yoshizawa moved to Tokyo in 1928 and attended evening classes in Tokyo. As is common for young men in Japan, he also studied in the Buddhist priesthood for two years, although not at a monastery. At the age of 22 he took employment as a draftsman in a machine-tool factory and was given the job of teaching geometry to the young apprentices – geometry which he did by means of origami. Called up into the Japanese army as a medical orderly in 1943, he decorated the beds of sick patients with origami until he was released from duty in 1945 – at which point he went back to his home town of Tochigi. Later he retuned to Tokyo to try to earn his living from origami. While he did give some demonstrations, he survived by doing quite menial jobs.

Yoshizawa's father was acquainted with a local headmaster, and through him Yoshizawa was invited to give a small display of his folding at a teachers' conference. Little by little, discerning people came to know of his remarkable folding skill, among them Tadasu Iizawa, famous playwright and editor of the picture magazine "Asahi Graf." The story is that Iizawa searched the streets for Yoshizawa and found him in an old army coat peddling tsukudani, which is a kind of fish delicacy. Yoshizawa accepted with delight Iizawa's commission to fold the twelve animals of the Japanese calendar, and Iizawa installed him in a hotel with a new set of clothes and an ample supply of paper. By a superhuman effort Yoshizawa completed his task in time, and photographs of his models were shown in Asahi Graf's January 1952 issue. In this way, his work came to the attention of the Japanese public, and Yoshizawa's fortune was made. By now he was aged forty. Tadasu Iizawa continued to take an interest in Yoshizawa's new origami, and he helped to arrange for the regular publication of instructions for

The Making of a Paperfolder:
Akira Yoshizawa

"Swans," created 1952, folded 1998

All five models in the swan family were made by employing the wet folding technique. The large swans were each folded from sheets of paper in the form of equilateral triangles.

014

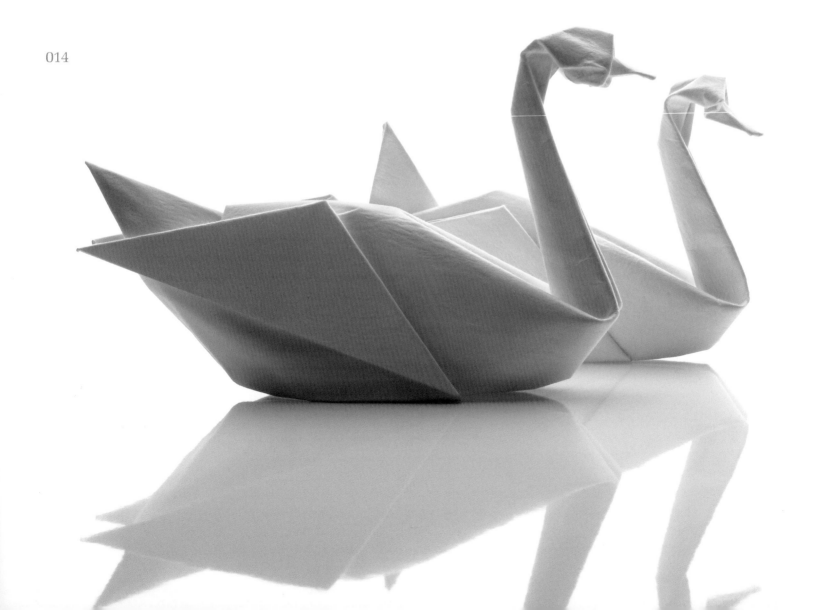

Yoshizawa's models in two Japanese ladies' magazines, "Fujin Koron" (Ladies' Opinion) and "Shufo no Tomo" (Young Ladies' Friend). In 1954 he helped to arrange an exhibition of Yoshizawa's work at the Ginza in Tokyo, an exhibition for which Yoshizawa folded many new models. Yoshizawa's first book was "Atarashii Origami Geijutsu" (New Paperfolding Art). This book of quite simple folds was published in 1954, and the title said much about Yoshizawa's approach to folding.

Yoshizawa's fame soon spread beyond Japan. By a fortunate twist of fate, knowledge of Yoshizawa reached Gershon Legman, an American paperfolding researcher who had moved to France to live in August of 1953. He made Yoshizawa's acquaintance and persuaded the artist to ship to him all the models from the Ginza exhibition. Legman then arranged for an exhibition of Yoshizawa's work at the Stedelijk Museum in Amsterdam in October of 1955, and this exhibition brought Yoshizawa instant fame in the West. Among the paperfolders who learnt of his work were Robert Harbin in England and Lillian Oppenheimer in New York, both of whom played significant roles in the formation of the new paperfolding movement in the West. Yoshizawa became one of the inspirations for the Origami Center, which Mrs. Oppenheimer founded in New York in 1958. In 1959 an exhibition of paper crafts was held at the Cooper Union Museum in New York, and Gershon Legman sent to it the models from the Amsterdam exhibition to form the centrepiece of a section on origami.

The success of the Amsterdam exhibition and Yoshizawa's growing influence moved the Japanese authorities, beginning in 1965, to send him to foreign countries as an ambassador for Japanese culture. In 1966 he visited Australia, New Zealand and the Philippines, and later trips took him all over the world. Often he was only able to give demonstrations of origami, but on his visits to Europe and the United States he was able to meet skilled Western paperfolders who responded enthusiastically to his concepts of folding. They, in turn, began visiting Japan. A privileged few of them were invited to visit Yoshizawa at his own home where they were able to see his own special collection of his models, carefully preserved for posterity in wooden boxes.

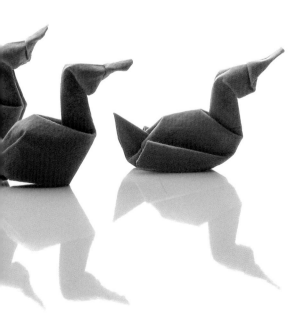

For the rest of his life Yoshizawa held residential meetings each summer, and his work was the subject of frequent exhibitions in Japan. The most impressive of these took place in the year 2000 in Tokyo, Kyoto and other Japanese cities, in celebration of his 88th birthday. He wrote over twenty books, although the models he included were rarely ones of high complexity. Yoshizawa also was recognised by the Japanese Emperor, who made him a Member of the Japanese Order of the Rising Sun. Yoshizawa was very aware that he was a master of origami. He could be a stern teacher, and he firmly opposed ideas which conflicted with his own. Yet he was warm-hearted and loved to teach children simple folds, such as a dog or a puppy, folds that would forgive the clumsiness of little fingers. His face shone with pleasure whenever something went particularly right. Largely because of his own initiatives, Origami in all its varieties is now a worldwide movement which is widely recognized by the general public. It is given to few artists to invent a new art form and to live to see it practised with such enjoyment throughout the world.

A Brief History of Origami

Koshiro Hatori

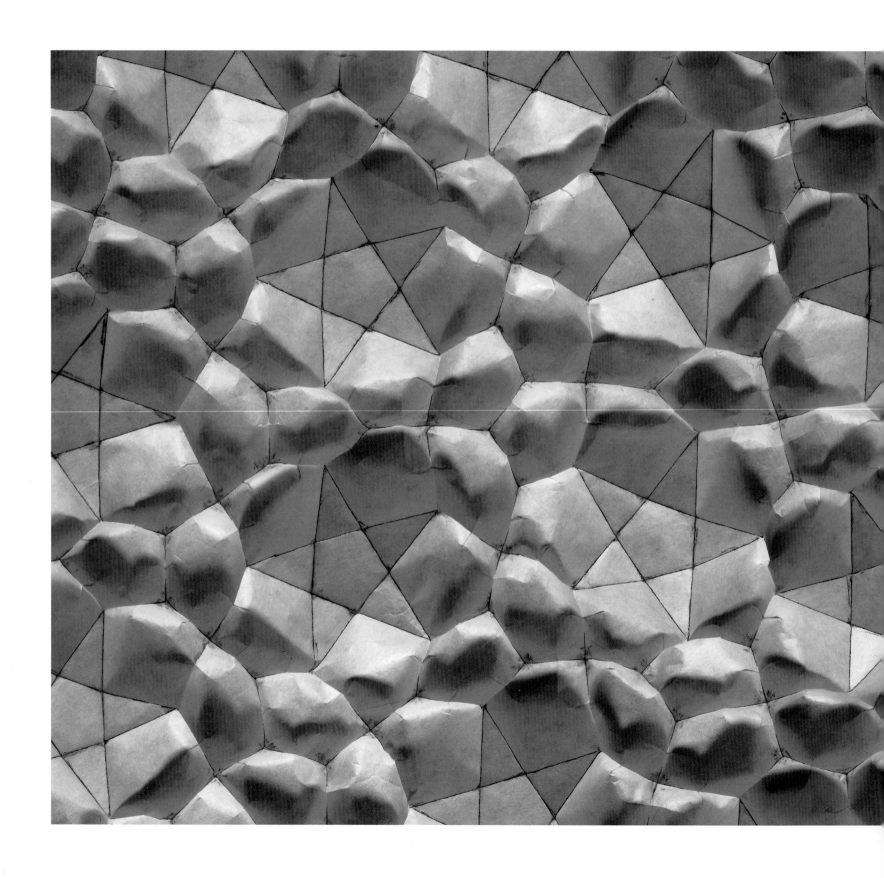

Japanese Classic Origami

It is sometimes said that origami originated in second-century (AD) China. This opinion was first expressed, as far as I know, by Lillian Oppenheimer in 1959. She wrote in the foreword to Honda Isao's "How to Make Origami" (New York, McDowell, Obolensky, 1959) that paper was invented in second-century China and that origami is as old as paper itself. However, both of her statements are problematic. First, the oldest paper ever found was made in Qianhan-dynasty China (202 BC–8 AD), much older than the second century. But we cannot blame her for this point, because such old paper was not known until the 1970s. Second, we have no evidence that origami is as old as paper. In fact, the paper of ancient China and Japan seems to have been writing material, not for folding. The Chinese character for paper, zhi, originally stood for writing material made of silk. The origin of the Japanese word for paper, kami, is said to be birch tree, kaba, or strips of wood or bamboo, kan. Both of them were also writing material. It seems that the history of origami is by no means long compared to that of paper. Origami is sometimes said to date back to Heian-Era Japan (794–1192), but Okamura Masao's comprehensive research, published in Origami Tanteidan magazine and "Oru Kokoro" (Tatsuno, Tatsuno City Museum of History and Culture, 1999), proves that all the suppositions about the opinion are irrelevant.

The oldest unequivocal document of origami is, according to Okamura's research, a kyoka, or a short comic poem in the haiku style, composed by Ihara Saikaku in 1680. It reads: Rosei-ga yume-no cho-wa orisue (The butterflies in Rosei's dream would be origami.). Here he referred to an origami model called Ocho Mecho (Male and Female Butterflies). Ocho Mecho is one example of ceremonial origami that has its roots in the manners of the samurai class. This kind of origami has been passed down by the Houses of Ogasawara, Ise, Imagawa, and others. According to Ise Sadatake's "Tsutsumi-no Ki" (1764, published in 1840 as a part of "Hoketu Zusetsu"), it dates back to the Muromachi era (1336–1573). Ceremonial origami is basically a formal way of wrapping. The most famous example is Noshi, which is the wrapping for noshi-awabi, or dried abalone, but usually used as a token of good luck today. And Ocho Mecho is the wrapping for sake bottles. Saikaku also described an origami of Hiyoku-no Tori (a bird of Chinese legend) in his novel "Koshoku Ichidai Otoko" (1682). Such kinds of representational origami are sometimes called recreational origami.

Examples include the well-known Orizuru (Crane), Komoso (known as Yakko-san today), Boat, Sanbo (Offering Stand), and a modular origami called Tamakebako. We do not know when these models arose. The models of recreational origami have been depicted in many ukiyoe (wood prints) and books since the 18th century. There were even fairly complex models at that time, and the adults, rather than children, were fascinated by them in the early 19th century. They folded paper in different shapes

"Birth Of Stars," April 2005

The model was folded out of a sheet of paper to create a polygon. Sheets of torinoko and kozo paper were glued and dyed with pastel paint. The model took its inspiration from the Penrose tile pattern.

A Brief History of Origami

with a lot of cuts. They also used many judgement folds. And the design was dependent on the quality of Japanese handmade paper, washi. To make a colored pattern, they laid some sheets of paper in different colors on each other, or painted them. The oldest existing folded pieces in Japan were formerly owned by the House of Moriwaki, and are now owned by Takagi Satoshi. They include ceremonial and recreational origami, and the latter are estimated to have been folded between 1800 and 1825.

European Classic Origami

Interestingly, the oldest folded origami pieces in Europe are also estimated to have been folded in the 1810s. They–origami horses and riders–are among the collections of the German National Museum, Nuremberg. The Saxon Folk Art Museum in Dresden also has origami horses and riders of the 19th century that have been thoroughly researched by Joan Salas. The models are similar to the famous European traditional model known as Pajarita (Little Bird) in Spain and as Cocotte (Hen) in France. European classic origami is well-documented in the context of child education, because origami has been an important part of education since Friedrich Froebel established the world's first kindergarten in the middle of the 19th century. His educational system included some toys called Gifts and plays called Occupations. Origami "is one of the most comprehensive Occupations," wrote Maria Kraus-Boelté and John Kraus in their "The Kindergarten Guide" (New York, E. Steiger, 1877). Froebel's gifts and occupations consist of three categories: forms of life, forms of beauty, and forms of knowledge. They folded origami models such as Pajarita, Sail Boat, Water Bomb (also known as Balloon), and Dart (the same as Paper Plane, but there was no airplane in the 19th century) in forms of life. In forms of beauty, they folded symmetric patterns starting from blintz fold or double blintz fold. Elementary geometry is taught in forms of knowledge, where origami plays the most important role. Only a few models of 19th-century European origami can be found in contemporary Japanese sources. Even now, very few Japanese know Pajarita though every Spaniard knows it. On the other hand, Orizuru was not known in Europe at that time though it was typical of Japanese classic origami. The models of European classic origami were based on creases of 45 degrees, whereas Japanese ones such as Orizuru or Frog were based on those of 22.5 degrees. They used only square or rectangular paper, and they did not use judgement folds or cuts very much. European and Japanese classic origami were so different that they seem to have developed independently.

We do not know exactly when European origami started. Water Bomb probably dates back to the 17th century, since the model seems to be the same as Paper Prison

Traditional Origami

referred to in John Webster's "The Duchess of Malfi," which was premiered around 1614 and published in 1623. The origin of European origami may relate to the baptismal certificate of the 16th and 17th centuries. At that time, they folded baptismal certificates into double blintz or the same shape as the Japanese model called Menko or Thread Holder. Even now, they use this type of folded certificates, or ceremonial origami, on celebratory occasions in Austria (Ann Herring, "Origami-no Bunkashikou" in "Oru Kokoro"). When Japan closed its border in the Edo Era (1600–1867), both the Japanese and the Europeans had origami cultures that were fairly independent of each other. The Meiji Restoration (1867) and the subsequent exchange between Japan and Europe caused a fusion of East and West origami. I would call it the first international origami exchange. The Japanese imported the Froebel's kindergarten movement, which contained European classic origami, when they remodeled their educational system on the European one. On the other hand, Western kindergartens adopted Japanese classic origami. Thus Japanese and European classic origami were mixed. The repertoire of origami evolved here has been handed down until now and formed the core of traditional origami. In traditional origami, the models are passed down from hand to hand, from generation to generation. And they change their shapes and titles frequently. Children, as well as adults, often make variations or even improvise new models. According to Okamura's research, the young readers of "Shokokumin" magazine contributed their creations frequently from 1892 to 1894 in Japan. This creativity of traditional origami was one of the reasons that Froebel included origami in his occupations. But in today's origami education, pupils just follow the sequence as taught. So teachers tend to misunderstand that origami is mere imitation, and exclude it from their programs. The models of traditional origami travel a long distance in a short time, sometimes beyond borders, as people move. Japanese Orizuru migrated to Europe and became Flapping Bird in the first years of the Meiji era. Then Miguel de Unamuno, who was active from the end of 19th century to the early 20th, made many models based on Flapping Bird. Although it has been most popular in Japan, origami has been inherited in Europe, and has spread out into the Americas, China, and other regions. New models have been added to the repertoire in each country, and they occasionally travel worldwide before being documented. For example, Maying Soong's "The Art of Chinese Paper Folding for Young and Old" (New York, Harcourt, Brace, 1948) contains, in spite of the title, both Japanese and European classics models, although some of them seem to be Chinese in origin. Sometimes it is quite difficult to identify which traditional model originates in which country.

A Brief History of Origami

Modern Origami

In traditional origami, the folding sequences and titles are passed down as something anonymous, not as something made up by a specific person. Uchiyama Koko (1878–1967), however, advocated intellectual property rights for his compositions and patented them. Thus, the models of modern origami became something designed by specific creators. In modern origami, some emphasize the aspect of origami as a puzzle: reproducing shapes of objects under a certain rule. The most common rule is to fold one sheet of square paper without cutting or glueing. Behind the rule, there is an implicit premise that origami models should be folded with origami paper, i.e., pieces of paper pre-cut into squares and colored on one side. Origami paper was first used in Froebel's kindergarten origami, and has been manufactured in Japan since the early 20th century. Soon it became canonical paper for the pieces of modern origami. In Japan of the 1950s and 60s, Uchiyama Kosho (the son of Koko) and Yoshizawa Akira led Modern origami, or Sosaku (Creative) origami, as they call it. At the same time, Gershon Legman did extensive research on origami, and introduced Yoshizawa's origami works in Europe and the U.S. Thus he connected creators and folders such as Yoshizawa Akira, Takahama Toshie, Honda Isao, Robert Harbin, Lillian Oppenheimer, Samuel Randlett, and Vicente Solórzano-Sagredo. This movement, which I would call the second international origami exchange, has advanced the popularization of origami. They published the origami models of the designers from Japan, Europe, and the Americas in Japanese and English. They also founded national and local organizations. "Origami" became a universal word because of Oppenheimer's proposal. Yoshizawa's notation of diagrams was adopted by Harbin and Randlett and became the international standard.

Mathematic Origami

The designing method in modern origami depends on a few existing bases, such as the bird base or the frog base. The bases are essentially halfway shapes that many origami models have in common. Some folders in the 20th century invented the notion of the base when they organized such halfway shapes according to geometric analysis. Early examples were published in Uchiyama Koko's "Origami Kyohon" (Tokyo, Nihon Shugei Bijutsu Kyokai, 1931), Nakajima Taneji's "Shuko Kyozai Origami Zaiku" (Tokyo, Kensetsusha, 1936), and Vicente Solórzano-Sagredo's "Papirolas: Tratado de Papiroflexia" (Valladolid, Librería Santarén, 1939-43). But they just organized and modified the existing bases, such as making a Bird base folded from a triangle or a combination of Bird base and Frog base. They hardly invented new bases until the 1980s, when Maekawa Jun and Peter Engel independently studied the geometric

aspect of the bases. Their "Viva! Origami" (Tokyo, Sanrio, 1983) and "Folding the Universe" (New York, Vintage Books, 1989), respectively, showed the way to make up new bases and paved the way for composing complex origami models. When we fold a base and unfold it, we get a crease pattern. Maekawa and Engel noticed that the crease patterns of established bases consist of particular triangles and rectangles. They divided a crease pattern into these "atoms," and rearranged them to make new crease patterns. The crease pattern defines the base, and the base defines the model. Thus, they designed origami models by creating crease patterns. In other words, they designed new models before they folded them. Such a mathematical way of designing origami models has been developed further by Meguro Toshiyuki, Kawahata Fumiaki, Robert Lang, and others. They devised algorithms that generate the crease pattern of any arbitrary base. Their investigation culminated in Lang's origami-designing computer program "TreeMaker" and his tome "Origami Design Secrets" (Natick, A K Peters, 2003).

Artistic Origami

In modern origami and mathematic origami, the aspect of origami as a geometric puzzle has been emphasized. But there is another aspect of origami: origami as art. Since the 1950s, Yoshizawa Akira has explored the expression of folding paper and demonstrated that origami has the potential to be a fine art. He has enhanced the expressiveness of origami and had a great influence on today's artistic origami. His works not only represent the appearance of the objects, but also show emotional expression. They are not lifelike. They live their own lives. In the 1960s, Uchiyama Koko created Kamon-ori or Flower Pattern Folding. It produces abstract patterns based on a geometrical expansion of Tato. Abstract origami itself was not new. In fact, it dates back to Froebel's origami of forms of beauty. But Koko shaped unique art works by folding multi-layered washi dyed by himself. Folders of artistic origami bring out the potential expression of the paper. Therefore, choosing paper is important. In addition, the folders often work on paper and improve its expressiveness. Uchiyama's Kamon-ori is an excellent example. Yoshizawa innovated the wet-folding technique, where we dampen paper before folding it to make curved shapes. He also tried the expression using cut edges of paper. Moreover, Michael LaFosse makes paper himself. Today, Western folders are more active in artistic origami. The exponents of abstract origami are Jean-Claude Correia, Paul Jackson, and Vincent Floderer, and those of representative origami are David Brill, Eric Joisel, Michael LaFosse, and Joseph Wu, among others.

The Perfect Paper

Michael LaFosse and Richard L. Alexander

022

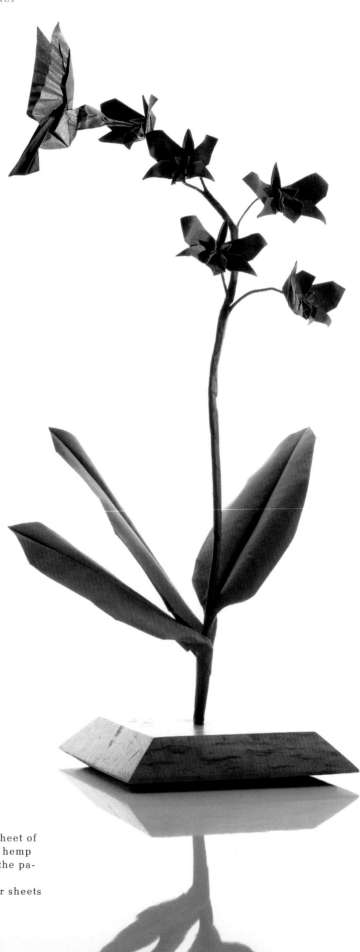

"Hummingbird on an Orchid,"
designed 1978, folded 2005

The hummingbird was folded from a square sheet of origamido duo paper, handmade from Manila hemp fibers. Black-green pigments tint one side of the paper, the other side is dyed red. The orchid blossoms were folded from single, rectangular sheets of handmade origamido paper.

Perfect Paper for Origami Art

While any paper can be folded, not just any paper is the correct choice for a fine piece of origami. Today we have a luxury of choices, machine and handmade, but surprisingly, relatively few paper-folders understand enough about paper to procure suitable paper for their art. This chapter will serve as a guide to the origami art collector, connoisseur, serious origami artist, or artist-to-be.

A Long History for Paper – a Short History for Origami as an Art Form

True paper is a thin mat of non-woven cellulose. Wasps were building nests from paper long before man developed the process, and we credit the Chinese for making true paper about 2,100 years ago. With trade, paper and papermaking techniques spread to Korea, Japan, and along the Silk Road to the Middle East and Europe. Papermaking machines were developed in 1798, and until it was mass-produced, paper was too rare and expensive for casual use. Origami as an expressive art form is quite recent – most of the origami art masters are still alive today!

Material Quality Matters

It is helpful to know the source of the fiber, and how the paper was made: methods, materials, chemicals, and ingredients can determine the life of the paper, and how time will affect its appearance. Papermaking methods, hand or machine, are as varied as the types of papers they produce. Finding just the right paper for an origami model can be a challenge, but the process of searching can be fun, educational, and rewarding when you finally find the best paper for your model.

Most of the earliest papers were designed for wrapping, writing, and printing, just as most are today. As papermaking spread, new uses emerged, and formulas were developed to produce papers better suited to those specialized needs. So called "origami paper" was originally developed to fill the need for inexpensive materials used in Friedrich Froebel's innovative Kindergarten curriculum, particularly popular in Europe, the U.S. and Japan during the last half of the 1800s. Today, many adults still use "origami paper," even though there are many better choices, including beautiful papers from fine-art, hand papermaking studios. True, most handmade papers are designed to serve other needs, such as bookbinding, pulp sculpting, or block-printing. Paper quality is by far the most important limitation to good origami, yet folders nearly always blame themselves if a model seems lacking. When choosing paper for origami art, the artist should consider aspects such as permanence. As a former chef, Michael uses a cooking analogy: "You can't make an exquisite Angel's Food cake if you only have egg yolks and whole-grain flour. Get the right ingredients for your purpose."

The Perfect Paper

Artistic Control

At Origamido Studio, we make special paper for origami art and for other origami artists. Hand papermaking techniques now enable the origami artist to assume control of their art with materials that truly help them better realize their vision.

We can now make strong, lasting papers, custom-colored for a specific origami model, of any size or thickness, and with any desired surface qualities, such as pattern, sheen, or texture. Surprisingly, papermaking is not so difficult, nor prohibitively expensive, and for the serious artist, it is well worth the effort.

Permanence

Although artistic control is important, there is another good reason for knowing about paper. You will want your paper art to last. Most origami folded from harshly processed, wood-based paper from only a few decades ago is now becoming brittle, faded, and brown. After investing perhaps years of effort designing and executing a modern origami masterpiece, why not use materials that will last?

The paper you choose must be lightfast so that colors will not fade, and acid-free. Generally, avoid papers that are made from wood pulp, dyed, or processed from short-fiber, post-consumer recycled fibers. Do choose paper that is made from high-quality fiber from cotton or linen rag, or from abaca (Musa textilus), flax (Linum usitatissimum), kozo or paper mulberry (Broussonetia papyrifera), gampi (Wikstroemia diplomorpha), mitsumata (Edgeworthia chrysantha), or hemp (Cannabis sativa).

Complex Designs Require Better Papers

Many complex and super-complex origami models designed and folded today require papers that can withstand repeated folding, and/or a buildup of layers without bursting – papers which are not readily available. When you can find the right type of paper, it is usually not in the right colors or size.

Today's designs often feature inside-out manipulations for clever, color-change effects. Popular "action models" feature movement that wears the paper at key stress points. Folders will often use laminated composites of different fibers and foils, and only a few will wet-fold these complex models from high-strength blends of fibers. Origami insect designs (such as those by Robert Lang and Satoshi Kamiya) require paper of exceptional strength and thinness. These complex designs have driven us to develop stronger, thinner blends of paper for origami art.

Wet-Folding Techniques Require Better Papers

One of the most important aspects in the development of origami as art is "wet-folding," which employs methods to moisten and lubricate the paper as it is folded. These methods increase artistic possibilities. Wet-folded models stay as shaped when dried, while dry-folded models can soon "relax" or appear tired.

Live-Paste Folding

The process of creasing paper can also damage the surface fibers, and many wet-folders will use additives, such as paper lubricants and glues, called "size." If you apply an even coat of methylcellulose or starch paste, the paper will feel as if it were a thin piece of soft glove leather. Wet-folding with size or "live paste" allows the fibers to bend and slide, rather than break. Internal size is required for some origami models, but we find there is no need to add it during the papermaking process, since it is just as easy to add size when moistening the paper for wet-folding.

Wet-Folding Expands the Artist's Palette

There are many beautiful papers that are too soft or too thin for folding unless first bonded to stronger paper. This process, called "back-coating" uses glue, methyl cellulose or wheat paste to bond the two pieces of paper, resulting in a thicker, stronger sheet more suitable for wet-folding. These wet-folding and back-coating methods have allowed folders to utilize exotic papers that are unsuitable for dry-folding.

Yoshizawa: Pioneer of Origami as an Art Form

Michael was inspired by the photos of Akira Yoshizawa's exquisite origami art masterpieces, as re-printed in a 1970 "Reader's Digest" article, which showed sculptural shapes that Michael knew were not possible from paper readily available to him. Yoshizawa's papers seemed much richer, heavier, and not as brightly colored as typical "origami paper." Michael began making his own when he was just a young teen.

His experimentation with brown grocery bags and a kitchen blender were encouraging, but he knew something was missing. Michael began to research a variety of papermaking techniques from workers in the local paper mills. (The nearby mill in Dalton, Massachusetts, made paper stock for the U.S. Treasury's money.) He met Elaine, Sydney, and Donna Koretsky, who had been conducting research on hand papermaking techniques from Asia and provided guidance to paper artists at their Carriage House Paper Museum in Brookline, Massachusetts. Eventually, he pieced together enough information and techniques to make his own, archival papers. Since 1988, we have worked together to make special papers for wet-folding his original, origami fine-art pieces, and since 1996, Origamido Studio has been offering these papers and papermaking services to other origami artists and masters.

The Process of Making Paper for Origami Art

The plant materials must be carefully harvested then processed to remove undesirable materials. We beat the fiber, blend, color, and form sheets by screening, pressing, and drying them in a variety of ways, to produce a wide spectrum of archival, colorfast, handmade papers suitable for any style of wet-folding.

The Perfect Paper

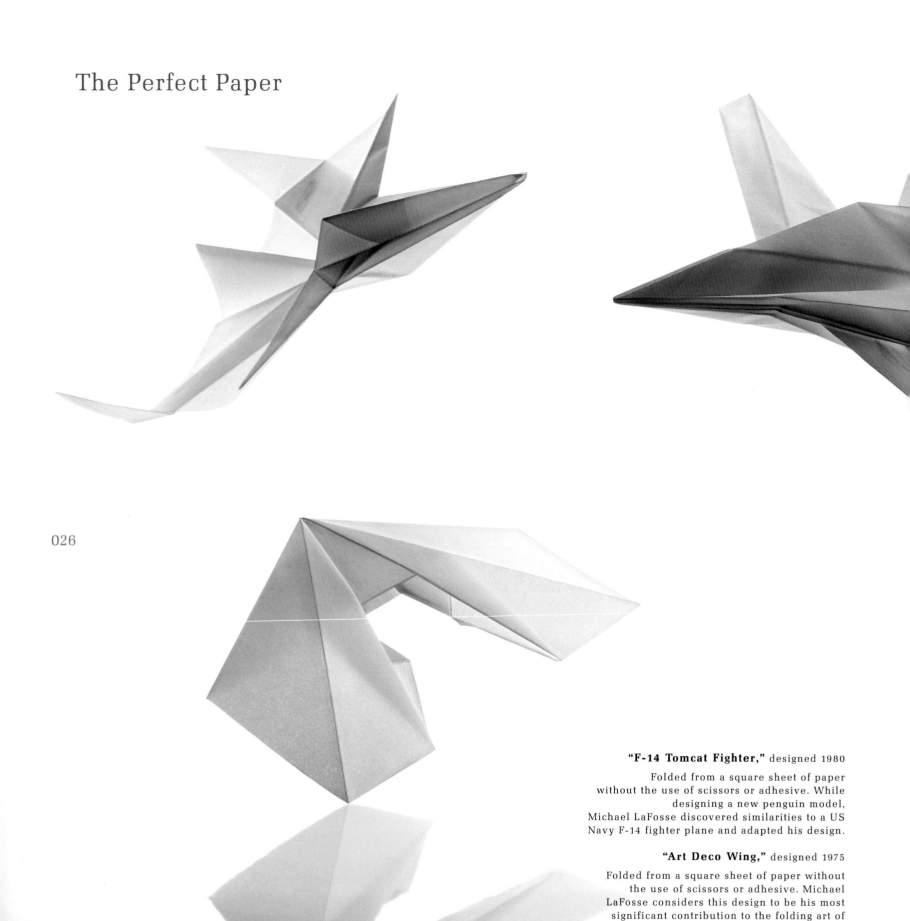

"F-14 Tomcat Fighter," designed 1980

Folded from a square sheet of paper without the use of scissors or adhesive. While designing a new penguin model, Michael LaFosse discovered similarities to a US Navy F-14 fighter plane and adapted his design.

"Art Deco Wing," designed 1975

Folded from a square sheet of paper without the use of scissors or adhesive. Michael LaFosse considers this design to be his most significant contribution to the folding art of paper airplanes.

"Flying Fox," designed 1980

Folded from a square sheet of paper without the use of scissors or adhesive. When viewed from above, the front of the model has a shape redolent of fox's head.

Fiber Sources

The source of the fiber largely determines the quality of the paper. The origami artist has a wide variety of fiber sources and should consider the advantages and disadvantages of each. The most common fiber we use for archival art is abaca. This fiber is from a plant in the banana family and is prized for its long, strong, relatively hard fibers. Cotton is also an excellent fiber for folded art. We find this soft, fuzzy fiber most desirable when making paper for an origami mammal, such as a squirrel or piglet. Other common plant fibers that we use for origami art include flax (linen), kozo (from the paper mulberry), and hemp.

Hydration by Beating

Beating or pounding the wet cellulose fiber with wooden mallets or within a specially-designed pulp beater, or "Hollander," separates and frays the cellulose strands, engorging the microscopic fibers with water molecules in a process called "hydration." All plants produce cellulose fibers – but throughout a broad spectrum of long to short, strong to weak. Some plants yield very little fiber of use to the origami artist. Plants with long, strong fibers are generally preferred, and fiber with optimal quality may come from a particular part of the plant, harvested in a particular season, at a particular age. Processing, such as beating, can also shorten the fibers (but never lengthens them). Different plants have different types of fiber, which require different beating times and conditions, so they must be beaten in separate batches before being blended.

Other factors impart strength to paper, including the degree of hydration and the amount of pressure used in the pressing and drying stages. We sometimes "loft-dry" our papers to conserve fiber strength. This unrestrained drying allows the fibers to tighten around each other, so the sheet becomes puckered and wild. We can then re-wet the sheets with a liquid size and flatten them in a second drying session, this time restrained between blotters, under pressure.

The Perfect Paper

Pigmenting Pulp

Coloring pulp can be difficult. Many commercial papers are dyed with organic chemicals that may quickly fade when exposed to sunlight, but inorganic pigments, such as carbon black, iron oxide, and titanium dioxides, are some of the most permanent colorants. Various mixtures of these finely ground inorganic minerals provide permanent earth tones in hues of browns, reds, and yellows. Pigment particles are usually insoluble in water, so we often must use chemical retention agents to help bond the colorant to the hydrated plant fibers. There are also several organic chemicals, many azo and phthalo compounds, which are sufficiently colorfast, offering other excellent choices for coloring paper. By first pigmenting different batches of pulp, then blending them, you can achieve almost any color you desire. Many origami animals–frogs, birds, insects, and butterflies–often seem more alive when we add pulverized mica to the formula. The sparkle adds a quality of depth to the paper, often catching the light in desirable ways when the works are exhibited.

Sheet-Forming

There are many methods for "pulling," or forming a sheet of paper. The most common method is to use a two-piece apparatus a framed, flat, rectangular screen, and a removable perimeter dam (or deckle)–to scoop pulp fibers from a suspension in a vat of water. After the water drains away from the pulp, the deckle frame is removed from the supporting screen, then the screen is inverted to transfer the mat of fiber onto a wet felt (couching). A stack of this wet paper, interspersed with wet felts, is pressed to remove water. The pressed layers of pulp are removed from between the felts and then dried to form a sheet of paper. Hand papermaking methods for one person can be exhausting if the deckle and frame (screen) is more than 20" wide. When we work together, we can handle larger frames, forming larger sheets. One person can also pour pulp slurry directly onto a large screen, or spray the pulp slurry onto stretched fabric, using a pattern pistol and an air compressor. (Some production studios have mechanical counterweights that allow one person to raise larger screens from the vat of pulp.)

At Origamido Studio, we use a glass table that measures six feet on each side, covered with a roll of felt six feet wide, upon which we can individually couch screened pulp, end to end, covering the entire glass. Many papermakers are not equipped to form such large sheets, since the methods for handling, pressing, drying, and storing the large sheets, and the related equipment – larger felts, blotters, and boards – are more costly, requiring more space, not only when used but also while stored between uses. One of our specialties is extremely thin paper, made from specially processed pulp. This pulp, called "over-beaten" or "high-shrinkage" pulp, is highly hydrated (more water molecules are incorporated within the microscopic strands of fiber). This type of pulp drains very slowly and demands greater skill to

make a good sheet. Over-beaten pulp makes paper that is extremely strong, and thin. With over-beaten pulp, we are able to couch two different pulps on the same felt to form a sheet with a different color on each side. This produces a thin, fine-quality "duo" paper, suitable for Michael's Ruby-Throated Hummingbird, white-bellied squirrel, Cardinal, toucan, penguin, or butterflies.

Dewatering

Pressing to remove water is a physical process, and there are many techniques available to the hand papermaker. The simplest is to stack the pulp on the felts between boards, then apply pressure. We press the paper with a 20-ton capacity hydraulic jack to remove water, which improves bonding, resulting in greater paper strength. This also enables us to more easily remove the wet, pressed sheet from the felts and place it between blotters or onto a drying surface. Another common method when forming large sheets is to cover the felt and pulp layer with a sheet of plastic, seal the sides, and impart a vacuum. The vacuum pump reduces the pressure between the table and the plastic, allowing the weight of the atmosphere to press water from the paper. Other papermaking presses use combinations of large rollers, levers, screw and crank-type mechanical devices, or hydraulic jacks.

Drying

The simplest method of drying a sheet of paper is to just leave it alone. This is called "loft-drying." If you want a flat sheet, you need to restrain it while it dries. If you brush it onto a flat surface, such as a piece of glass, smooth board, or a metal pan, the contact side will be as smooth as the surface you choose. Many commercial driers have heated, polished, metal pans, and we use an electric dryer for test sheets (to check color and strength). When we produce paper at the Origamido Studio, we currently make between 100 and 200 sheets at a time, so we restrain the paper between blotters and use a Santa-Ana-style, forced-air drying box. We separate the blotters and wet sheets of paper with pieces of corrugated cardboard and set up a 20" box fan to blow air through the corrugations, usually overnight.

Closing

Since we opened the Origamido Studio in 1996, we have refined our hand papermaking methods considerably, but we still fondly remember the papers we used to make years ago with relatively primitive equipment, and how much fun it was to fold those quality papers into special creatures. They have become our cherished friends!

If you, too, love paper, you probably also enjoy the adventure of discovering papers from rare fibers and exotic blends. If you are like us, you will try to learn as much as you can about various papermaking processes. Despite the huge universe of available papers, if you want the perfect fiber, color, texture, thickness, size, and strength, you may just want to try to make your own paper, too!

The Application of Origami to Mathematics and Science
Robert J. Lang

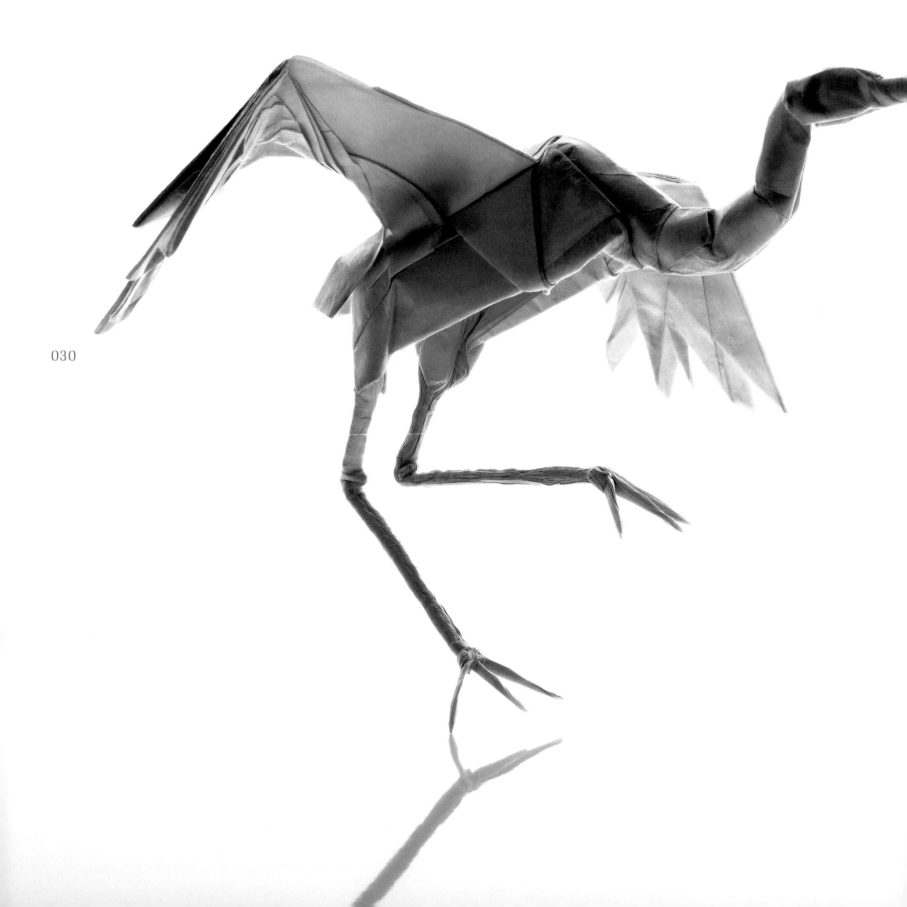

Foundations of Origami Mathematics

Origami and science: one is an ancient craft and modern art form, the other a field of logic, rationality, and empiricism. What could these two fields of endeavor possibly have to do with one another? Surprisingly, quite a lot. As origami has developed and matured as an art form over the course of the twentieth century, its artistic ideals have been advanced by the application of mathematical principles and scientific investigation, thereby elucidating what forms are possible and how they may be achieved. Even more surprising, perhaps, is that the techniques and knowledge of origami, although initially pursued to further artistic goals, have turned out to have practical applications in industrial design, medicine, packaging, the space program, and other areas of science.

While the roots of origami go back hundreds of years, most of its development as an art form took place within the last century. The German educator Froebel recognized in the nineteenth century that paper-folding can be used to exercise hand-eye coordination, and an early twentieth century book, Geometric Exercises in Paper-Folding by T. Sundara Row [1], collected various mathematical relationships that could be expressed or otherwise investigated through folding. However, most of the mathematical and scientific development of origami has taken place within the last 50 years.

Starting in the 1970s, several folders began to systematically enumerate the possible combinations of folds and to study what types of distances were constructible by combining them in various ways. A systematic study was carried out by Humiaki Huzita [2–5], who described a set of six basic ways of defining a single fold by aligning various combinations of existing points, lines, and the fold line itself. These six operations have become known as "Huzita's Axioms" (HA). Starting with any set of points and fold lines, Huzita's operations allow one to create new fold lines while the intersections between old and new lines define additional points. The expanded set of points and lines may then be further expanded by repeated application of the operations to obtain further combinations of points and lines.

The six operations identified by Huzita are shown in Figure 1.

"Dancing Crane, Opus 460," 2005
Folded out of an uncut, square sheet of Korean Hanji paper without using scissors or adhesive.

The Application of Origami to Mathematics and Science

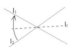

Figure 1: The six operations of Huzita's Axioms. Given two points p1 and p2, we can fold a line connecting them.

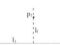

2. Given two points p1 and p2, we can fold p1 onto p2.

3. Given two lines l1 and l2, we can fold line l1 onto l2.

4. Given a point p1 and a line l1, we can make a fold perpendicular to l1, passing through the point p1.

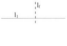

5. Given two points p1 and p2 and a line l1, we can make a fold that places p1 onto l1 and passes through the point p2.

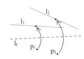

6. Given two points p1 and p2 and two lines l1 and l2, we can make a fold that places p1 onto line l1 and places p2 onto line l2.

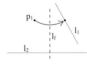

Figure 2: Koshiro Hatori's 7th axiom. Given a point p1 and two lines l1 and l2, we can make a fold perpendicular to l2 that places p1 onto line l1.

The set of points constructible by repeated application of HA to some initial set of features—typically, the corners and edges of the unit square—are of both academic and practical interest. From the academic side, it has been shown that HA can be used to construct distances that are solutions to cubic equations by sequential single folds. In particular, elegant constructions have been presented for two of the three great problems of classical antiquity that are not possible with compass and unmarked straightedge: angle trisection and doubling of the cube. On the practical side, HA can produce both exact and approximate folding sequences in only a few folds.

It has been shown mathematically that operations O1–O5 can be used to construct the solution of any quadratic equation with rational coefficients. Operation O6 is unique in that it allows the construction of solutions to the general cubic equation.

Recently, a 7th operation was proposed by Hatori [6], which I will denote by (O7). It is shown in Figure 2.

Hatori noted that this operation was not equivalent to any of the other six axioms. Hatori's O7 allows the solution of certain quadratic equations (equivalently, it can be constructed by compass and straightedge). If we denote the expanded set as the "Huzita-Hatori Axioms" (HHA), it turns out that this set is complete; these are all of the operations that define a single fold by alignment of points with finite line segments.

The set of 7 Huzita-Hatori axioms permits the solution by folding of a wide range of geometric constructions, including angle trisection [7–9], cube roots [10], regular polygons [11–14], and the solution of various cubic and quartic (fourth-degree) equations, entirely by folding. Of course, such equations can be solved by many other means. Further development of the mathematical laws of origami have defined mathematics of crease patterns, angles around vertices, and numbers of creases at vertices. Laws have been formulated and proven, and in some cases named after their discoverers: Justin, Kawasaki, Maekawa, Husimi, Fujimoto, Hull, and more [15–16]. The development of this mathematical theory underlying origami has served as the foundation for the development of an array of connections between the world of mathematics and the world of origami — and ultimately, to the development of applications of origami in the real world.

Applications to Art

The first utilitarian applications of mathematics to origami arose in connection with the design of origami figures for artistic purposes. Throughout the 1960s and 1970s, origami artists strove to create ever more realistic subjects and sought to take on ever

more complex subjects. Among the most complicated of natural subjects were arthropods: insects, spiders, crustaceans and their relatives, which all have many long, slender legs and often numerous additional appendages: claws, horns, antennae, and wings. To meet this origami challenge, a number of artists began to develop and apply mathematical methods to the creation of origami art.

This practical application of origami mathematics revolves around the study and creation of "flaps." In origami, a flap is any bit of paper that gets transformed into some feature of the finished subject. The origami artist seeking to fold a particular subject — a bird, for example — would first count the number of appendages in the finished subject and then seek to construct a base, which is an abstract shape that has a flap for every appendage of the subject. From the base, a series of shaping folds could be performed that would turn the abstract shape into a recognizable form. But the key to the process was the construction of the base itself, and that is where the origami mathematicians and scientists focused their efforts.

The concepts that led to mathematical algorithms for origami design can be seen by studying a single origami flap, as shown in Figure 4. A single origami flap is easily constructed from a square. In fact, all that one has to do is fold the square in half along a diagonal, then in half again, and eventually, one comes up with a long, skinny triangle that can be called a flap.

If we fold a line across the flap to delineate it, as shown in Figure 4, then we can call everything above the line the "flap" and everything below it "everything else," i.e., it is leftover material that can be used for other things (perhaps other flaps). If we unfold the flap and examine the crease pattern, we can clearly see the region of the paper that went into making the flap (a quarter of an octagon); we can further see that everything that lies outside of the octagon is part of the "leftover" paper.

Now, a little thought experiment. Suppose we made the flap narrower and narrower, as shown in Figure 5, before unfolding it. As we increase the number of folds, the boundary of the flap on the crease pattern becomes ever-smoother, and as the thinness of the flap increases, it eventually approaches a smooth circle.

In the early 1990s, several folders, including myself and Japanese biochemist Toshiyuki Meguro independently realized that circles could be used to represent flaps in

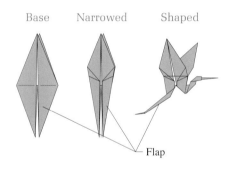

Figure 3: An origami base and its flaps. There is a flap for each appendage of the subject.

Base Narrowed Shaped

Flap

Figure 4: Formation of folding a single flap.

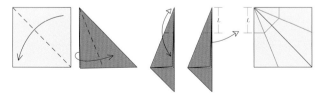

The Application of Origami to Mathematics and Science

Figure 5: Thinning the flap makes its boundary smoother. In the limit of an arbitrarily thin flap, the boundary of the flap in the crease pattern becomes a circle.

the design and construction of crease patterns. We found that no matter what part of the paper was used to make a flap, the region of paper needed for the flap was always approximated by a circle, whether the flap came from a corner of the square, the edge, or even the middle of the paper, as shown in Figure 6.

From this simple insight, we learned that we could design bases with multiple flaps by simply arranging circles on the paper, one for each flap, in which the radius of each circle was determined by the length of the corresponding flap. With the development of additional rules for filling in the creases on top of and between the circles, the design of a complicated subject like a spider could then be pursued in a systematic, direct way.

Figure 6: Whether a flap comes from the corner, edge, or middle of the paper, it always consumes a region of paper that is roughly circular.

Figure 6: Whether a flap comes from the corner, edge, or middle of the paper, it always consumes a region of paper that is roughly circular.

034

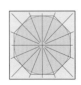

This method of design caught on widely in the origami world, and circle-packing, plus assorted improvements and variations, led to a veritable explosion of origami arthropods. In fact, it led to a trans-Pacific competition, known informally as the "Bug Wars," in which various origami artists sought to one-up each other by designing and folding ever-more complicated subjects. Although the focus of mathematical origami design was on the technical methods of design, a surprising outcome of the development of mathematical methods of folding was a renewed focus on the art form. For years, those developing complex subjects spent most of their energies on the development of the base; the shaping of the finished model came almost as an afterthought. Once the development of flaps could be pursued in a systematic, almost mechanical way, the construction of flaps was no longer the focus of design. Origami artists could instead take flap generation almost as a given, and could once again devote their energies to the artistry and execution of the finished form. Thus, the development of origami mathematics was the direct instigator of a renaissance in the art. Even more surprising, some of the techniques of mathematical origami design turned out to have application far beyond their original conception.

Figure 7. Left: the circle packing and crease pattern for a spider. Middle: the base. Right: the completed subject.

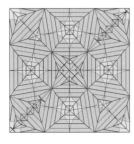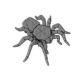

Applications in the Real World

The development of origami algorithms for design has led to the invention — or perhaps, discovery — of origami concepts and structures that have found application in the real world of industrial design and advanced research and development. The applications range from medical devices to automotive design to structures for space. A common feature of most origami in technology is a two-state sheet-like structure. The technological device must possess two distinct states: a large, flat, sheet-like state, and a much more compact state — which is typically used for transportation and/or

storage. For such a structure, folding is the natural mechanism to shift between the two forms, and among the rich variety of structures that have been uncovered in the years of artistic exploration of origami, one can often find a structure that exactly fills the bill.

Origami technology can range widely in size. One of the smaller structures, recently developed at Oxford University in England and Tulane University in Alabama, is a device known as an "Origami Stent Graft," which is a heart implant. The stent graft is a small tubular shape that is inserted into a blocked, or almost-blocked coronary artery and expands to hold the artery open. Dr. Zhang You at Oxford University and his student Kaori Kuribayashi developed a family of collapsible metal structures that can serve as stent grafts. This structure was based on a family of patterns composed of repeating elements of an origami base known as the Waterbomb Base.

Yet another application of origami to technology is found in space exploration. The "Eyeglass" project was a concept developed at Lawrence Livermore National Laboratory for an orbiting telescope with a 100-meter diameter primary lens. Livermore engineers Roderick Hyde and Sham Dixit turned to origami to find an appropriate folding structure.

After examining several origami patterns, the Livermore engineers settled on a pattern that folds up in a way somewhat reminiscent of a collapsible umbrella. They used this pattern in the fabrication of their first prototype lens, which at 5 meters in diameter is considerably smaller than the eventual goal, but still twice the diameter of the Hubble. The folding pattern reduced the diameter of the lens by about a factor of 3, but was readily scalable to larger diameters.

In some cases, origami math has advanced technology not by contributing specific folding patterns, but by contributing folding algorithms. A prime case in point came in the area of airbag design for automobiles. Airbags are typically designed using a computer simulation in which the airbag surface is divided into many small triangles and the positions of the corners of all of the triangles are computed as the simulated crash takes place. The whole simulation starts with the airbag tightly folded up in the steering wheel. The computer codes require that the edges of the triangles run along the folds in the folded-up airbag, which means that companies that are simulating airbags need to compute where the folds are going to go when the airbag is flattened.

The Application of Origami to Mathematics and Science

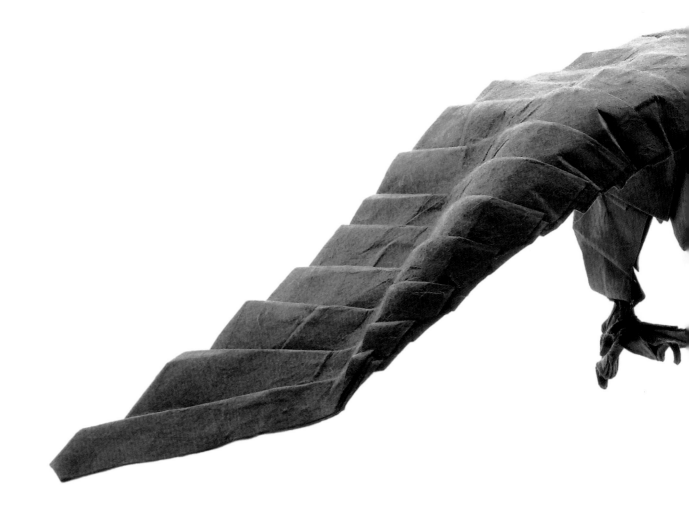

036

"Golden Eagle, Opus 426," 2003

Folded out of an uncut, square sheet of Korean
Hanji paper without using scissors or adhesive.

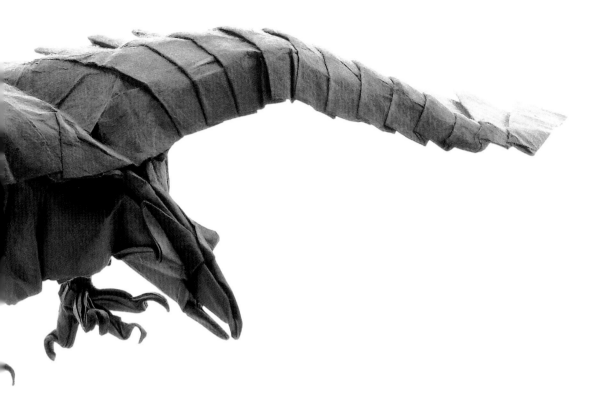

Since engineers design airbags in all shapes and sizes, this meant that the airbag simulators needed to be able to compute the creases that would flatten an arbitrary-shape airbag; once they had the creases, they could divide the surface up into triangles by adding lines and corners to the basic crease pattern.

Once again, origami provided the solution, but from a surprising source. It turned out that one of the mathematical algorithms used in artistic origami design, called the "Universal Molecule," was good for more than just designing birds and insects from squares: with small modifications, it could also provide the crease pattern for flattening airbags! And so the engineers at EASi Engineering GmbH incorporated this algorithm into their software and developed a full airbag simulation.

The application of an origami algorithm to a practical design problem illustrates a phenomenon that is not uncommon in the sciences: a mathematical or scientific effect is studied and analyzed out of purely academic curiosity. But it then turns out to have practical application in our daily lives. In the case of origami, the study of origami and its underlying mathematics is a field that is being increasingly pursued for its mathematical and artistic beauty. But as the examples of the origami stent graft, telescope, and airbag show, it can not only be practically useful; it can even save lives. Origami has come a long way from the frogs, birds and fish of its humble origins.

The Application of Origami to Mathematics and Science

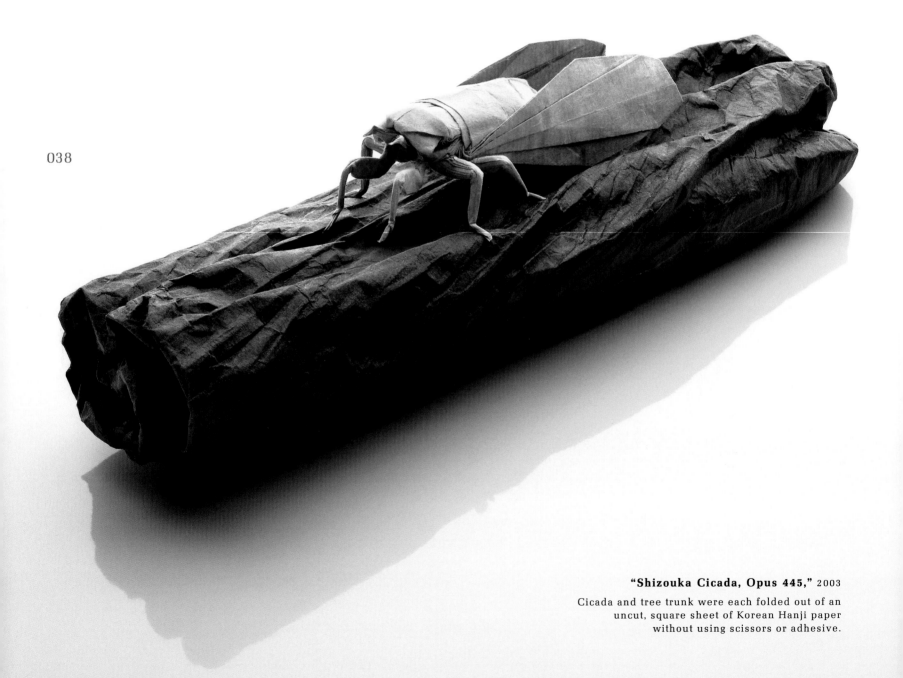

"Shizouka Cicada, Opus 445," 2003
Cicada and tree trunk were each folded out of an
uncut, square sheet of Korean Hanji paper
without using scissors or adhesive.

[1] T. Sundara Row, Geometric Exercises in Paper Folding, Open Court Publishing, 1905.

[2] Humiaki Huzita and Benedetto Scimemi, "The Algebra of Paper-Folding (Origami)," Proceedings of the First International Meeting of Origami Science and Technology, H. Huzita, ed., 1989, pp. 215–222.

[3] Humiaki Huzita, "Understanding Geometry through Origami Axioms," Proceedings of the First International Conference on Origami in Education and Therapy (COET91), J. Smith ed., British Origami Society, 1992, pp. 37–70.

[4] Thomas Hull, "Geometric Constructions via Origami," Proceedings of the Second International Conference on Origami in Education and Therapy (COET95), V'Ann Cornelius, ed., Origami USA, 1995, pp. 31–38.

[5] Thomas Hull, http://web.merrimack.edu/hullt/geoconst.html, 2003.

[6] Koshiro Hatori, http://www.jade.dti.ne.jp/~hatori/library/conste.html, 2003.

[7] Tsune Abe, described in British Origami, no. 108, p. 9, 1984.

[8] Koji Fusimi, "Trisection of angle by Abe," Saiensu supplement, October, 1980, p. 8.

[9] Jacques Justin, described in British Origami, no. 107, pp. 14–15, 1984.

[10] Peter Messer, "Problem 1054," Crux Mathematigorum, vol. 12, no. 10, December, 1986.

[11] Robert Geretschläger, "Euclidean Constructions and the Geometry of Origami," Mathematics Magazine, vol. 68, no. 5, December, 1995, pp. 357–371.

[12] Robert Geretschläger, "Folding the Regular Triskaidekagon," presented at AMS Joint Mathematics Meeting, Baltimore, MD, January 9, 1998.

[13] Robert Geretschläger, "Folding the Regular 19-gon," presented at AMS Joint Mathematics Meeting, Baltimore, MD, January 9, 1998.

[14] Robert Geretschläger, "Solving Quartic Equations in Origami," presented at AMS Joint Mathematics Meeting, Baltimore, MD, January 9, 1998.

[15] Proceedings of the First International Meeting of Origami Science and Technology, H. Huzita, ed., 1989.

[16] Origami^3, Thomas Hull, ed., AK Peters, 2002.

Folding & Unfolding in Art & Design
Paul Jackson

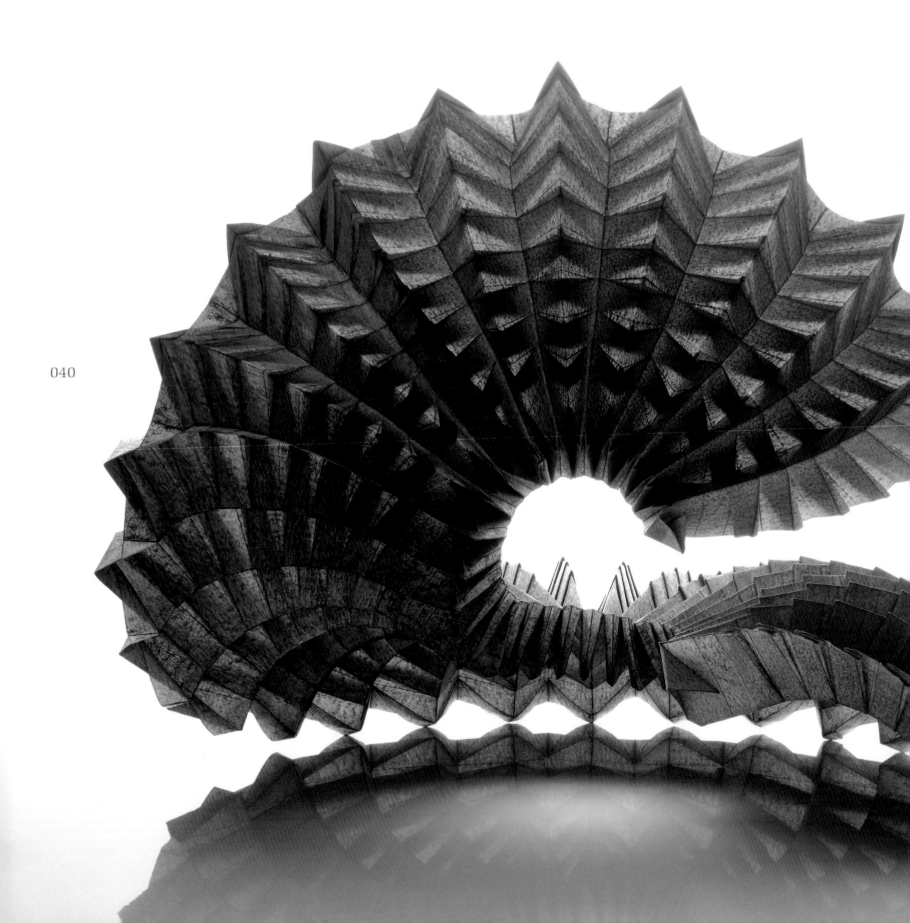

The Concept of "the Fold"

"Organic Abstract," February 2005

Folded from a long, rectangular sheet of paper made from gluing together four individual sheets of paper.

For a moment, don't think about "origami." Think about "folding." Folding can be one-dimensional – that is, a folded line. Examples include fingers, elbows and other joints, handwriting, a bent metal pipe, woven or knitted cloth, and the spiral flex on a telephone cable. Folding can be two-dimensional – that is, a folded surface. Examples include the creases in skin, an origami elephant, the ruffles in clothes, a bird's wing, a hinged door, and a leaf. Folding can be three-dimensional – that is, a folded volume. Examples include kneaded clay or dough, steam rising out of a kettle, a slowly swirling galaxy, and sea currents.

Whatever the dimension, folding can be articulated (moving) or non-articulated (not moving). Examples of articulate folding include a chain bracelet (1-D), turning the pages of a book (2-D), and smoke from a cigarette (3-D). Examples of non-articulate folding include the bent metal of a chair leg (1-D), the zigzag roof of a factory (2-D), and marbling in a sponge cake (3-D).

Take a few moments to look around you and make a list of what is folded in one, two, and three dimensions and which of these examples are articulated or non-articulated. The list will be surprisingly long! Folding is an essential element in both the natural and in the manufactured worlds. It is impossible to conceive of a universe without the phenomena of folding, at all scales from the molecular through the geological to the astronomical.

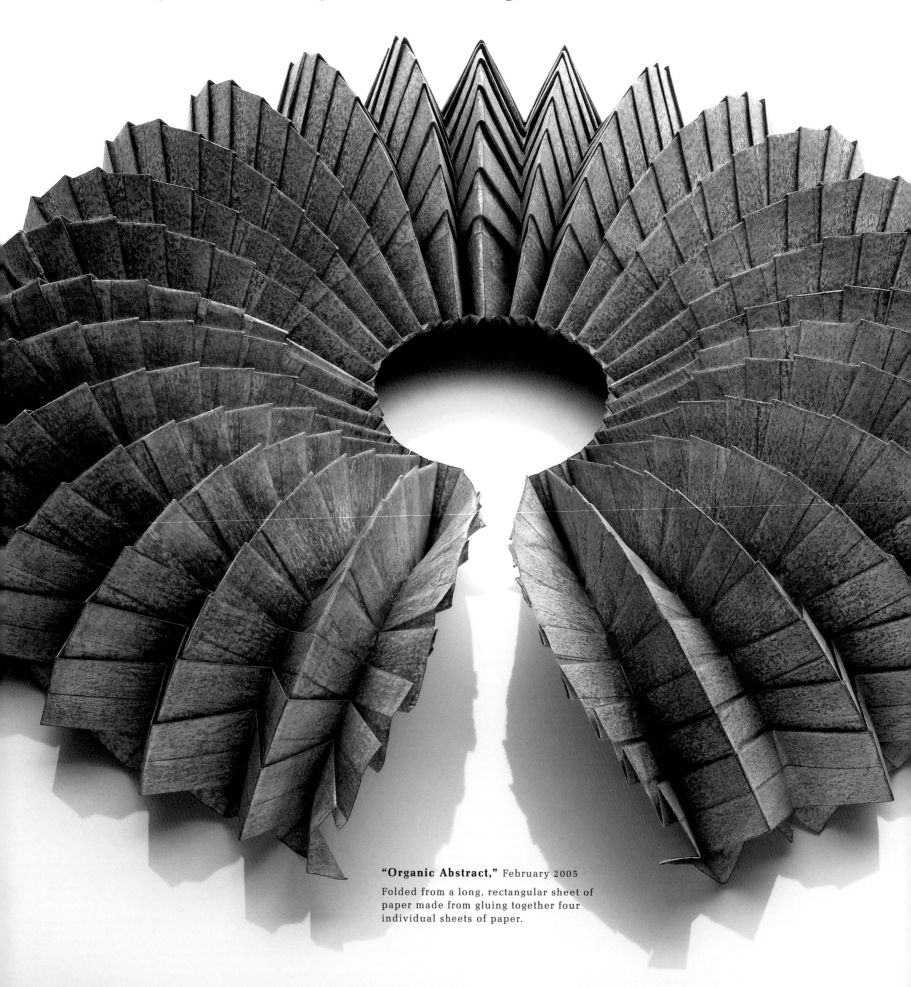

"Organic Abstract," February 2005
Folded from a long, rectangular sheet of
paper made from gluing together four
individual sheets of paper.

Folding in Design

All designers fold, but few designers are origami experts. Folding can include manipulation concepts, such as bending, curving, crumpling, twisting, collapsing, creasing, pleating, scoring, wrinkling, wrapping, gathering, spiraling, and all the opposites (unbending, uncurving, untwisting, etc). Sometimes the folding is a deliberate part of a design, such as the folding of the bellows in a large-format camera, and sometimes it is the unintentional by-product of use, such as the creases across a well-worn pair of leather shoes.

Almost all manufactured objects are made either from 1-D linear materials, such as thread or piping, or 2-D sheet materials, such as cloth, sheet metal, sheet plastic, or fibrous pulp (paper and cardboard). Few manufactured objects are made from solid 3-D volumes of material. The manipulation in some way of 1-D and 2-D materials is almost inevitable, leading to the almost inevitable occurrence of some kind of folding in designed objects.

There are a few designers noted for their sophisticated use of folding techniques. The most renowned is the Japanese fashion designer Issey Miyake, who has often described his folded and crumpled creations as "origami." His designs combine an interest in traditional Japanese ways of folding clothes, with conventional origami techniques and a re-working of the imprecise pleating technique originated by Fortuny, to create stunning pieces that are both geometric and organic.

Inputting key words such as "origami," "folding," "design," and "product" into an Internet search engine will bring up many interesting examples of the application of folding techniques in design, including maps, bicycles, furniture, jewelry, packaging, architectural structures, and apparel. It is apparent that the use of folding techniques in design has become more common in recent years than in former times. Perhaps the growth of interest in origami as a sophisticated and creative art form has inspired designers to likewise try their hand.

The Teaching of Folding Techniques in Design Education

Bauhaus

The earliest known teaching of folding techniques specifically to students of design was at the influential Bauhaus in Dessau, Germany. On the Grundlagen (Foundation) Course, Josef Albers taught paper-folding as a means to understand the movement and occupancy of 2-D planes in 3-D space, which he considered one of the fundamental components of design. His knowledge of folding as a model-making activity probably didn't rise above the simple traditional designs he most likely knew as a boy, such as the paper dart, but his teaching of geometric paper-folding reached surprisingly sophisticated heights. One of his projects was to challenge his students to design a folding pattern that would expand a single thickness of paper to a flat

sheet in one pulling movement, not only horizontally or vertically (such as a simple accordion pleat would do), but horizontally and vertically. Try it! There are many interesting solutions.

Although the Bauhaus became the blueprint for almost all design education in the West from the mid-20th century to the present day, the teaching of paper-folding did not generally survive.

In the early 1980s I conducted a series of folding workshops for designers at Siemens GmbH in Munich and Erlangen, Germany. I was introduced to a very elderly retired man who had once been a senior designer and who had been given an honoray studio in which to pursue his own interests and to occasionally advise on new projects. Upon hearing why I was visiting Siemens, he beamed widely. He opened a large plan-chest drawer in which were stored numerous grubby and clearly very old examples of folded paper. "I made these with Albers," he explained. "I still use them today when I'm stuck for inspiration."

044

My Own Teaching

Since 1982 I have taught "Manipulation Techniques" to students of art & design. My diaries suggest I have taught on more than 120 college-level courses, to students of fine art, fashion design, jewelry design, ceramics, architecture, industrial design, product design, graphic design, packaging, textile design, and interior design. I consider it the only design topic that can be taught to such a diversity of art & design students, other than the traditional essentials of drawing and color (and perhaps additionally now, computer studies). The connection between origami and design studies may not be immediately apparent. Initially, it wasn't apparent to me, either. Why should a student of design learn how to fold an origami elephant? What would be the point of learning such a model?

The obstacle to understanding the link is to assume that origami is a model-making activity – that the aim of folding paper is to make an easily recognized representation of an easily recognized subject (usually an animal, object, or geometric form). However, if the concept of the "model" is dropped, then suddenly folding becomes a technique immensely more open-ended than before.

This teaching of open-ended folding techniques without reference to model-making is – for me – the key to teaching origami to students of design. Frankly, there is little need to teach an origami elephant. To do so would be to simply teach how to make one specific model, fun though it may be. More useful is to teach generic techniques

which can later be applied in unlimited ways to creative project work. Over the years, I have developed a series of mini-workshops, each of which takes a simple technical idea such as a Reverse Fold or a regular Accordion Pleat and multiplies them, places two in opposition, places two side-by-side, has one growing from another, in a long series of variations that may eventually become technically very complex, but which can all be identified as originating from a simple technical origin. In this way, by folding all the examples for themselves, students learn how they, too, can develop new forms from familiar techniques, simply by thinking of different variations and folding the paper to see what may happen.

Sometimes the result is good, sometimes so-so, and sometimes it doesn't work at all, but usually, new ideas are found to move the technical exploration forward until something satisfactory – and usually unexpected – is found. Basics are basics, and I often teach the same techniques to a wide diversity of students, who then use them in widely differing ways according to their own design specialties.

The number of workshops and their content depends on the time I have with a group of students. Generally, I would spend about a third of the time teaching group work-shops and two thirds of the time allowing the students to create individual project work.

Once the workshops are completed, the project work can begin. I encourage the students to use materials other than paper, including fabric, plastic, metal, or leather. I also encourage the students to cut, to use multiple materials, to find creative ways to join pieces together, and to treat the concept of folding with as much disrespect as necessary in order to achieve a better piece of work. I am not a purist. During the project I help the students individually, hoping to speak to each student during each day of work in the college (the students also work at home).

The students are encouraged to begin their projects in one of three ways: by exploring a specific folding technique to see what ideas for a piece of work will emer-ge; to see how folding techniques can be applied to a favorite material or manu-facturing process, then to see what ideas for a piece of work emerge; and finally to see how folding techniques and materials can be applied to a student's current favorite object, such as a chair or hat. Often, a project will begin tentatively and take several wrong turns or meet several dead-ends. It is common for an idea for a hat to suddenly become a shoe, a necklace to become a ring, or a chair to become a table, and I encou-rage this fluidity. The biggest problem is often how to translate the folding techniques that worked well in paper in the workshops into other materials, so that the technique continues to look good. If this technical problem can be solved

Folding & Unfolding in Art & Design

"One Crease," February 2005
Folded according to the wet folding technique from
a rectangular sheet of watercolor paper.

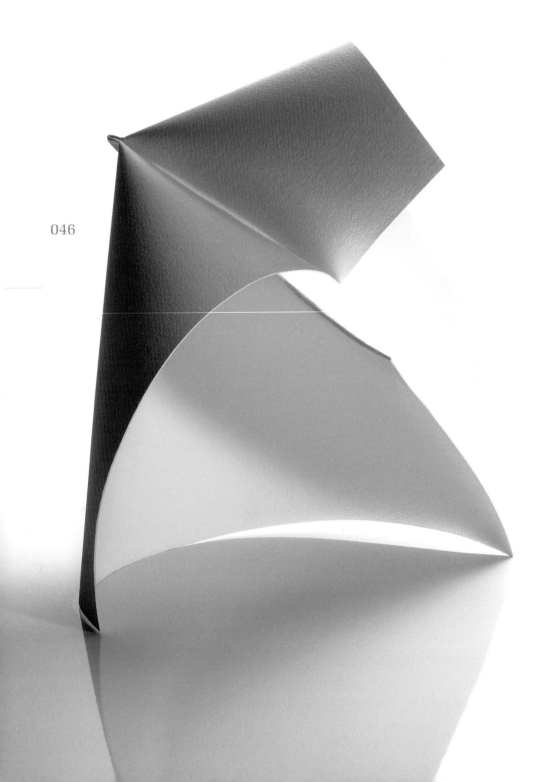

satisfactorily, the project is usually very successful. It is important to stress that although these projects are essentially "folding" projects in inspiration and content, a high level of folding knowledge and folding ability is not necessary to design an excellent final piece of work. Indeed, students with an unusually high technical ability often create the least successful project pieces! They forget they are designers, becoming technicians instead.

For many students, the folding project is one of their most memorable projects, I think for several reasons:
• The students feel they are learning something useful which can be applied to any future piece of work at any time.
• Results are usually quick to achieve.
• It is an intensively "hands-on" project. In contrast to most student projects, ideas are found in the hand, not conceptualized beforehand. Many students find conceptualizing difficult and irrelevant.
• The results are often impressive and much admired.
• Perhaps also over the years, I have learned how to pull the best from a student, by being supportive and enthusiastic about their work, by gently but firmly pushing them to improve and improve, to instill a sense that creativity should be enjoyable, by allowing them to fail, by being critical in a positive way, and by always showing respect to a student. If it is true that to like a subject, a student must first like the teacher, then I take some satisfaction as a successful conduit between a student and the techniques of folding.

Conclusion

There can be no doubting the importance of folding in design. It is one of the essential elements which go to make almost any manufactured object. In one way or another, all designers are folders, though few are skilled in the techniques of origami. In my opinion, folding techniques should be taught to all students of design as one of its fundamental components.

Paul Jackson

Paul Jackson has been a professional paper-folder since 1983. Among a great diversity of activities, he has taught "Manipulation Techniques" on more than 120 art & design courses, written 24 books on origami and the paper arts, and undertaken many media commissions. His folded paper sculptures have been exhibited in galleries and museums around the world. In 2000 he met and married Miri Golan, the founder (in 1993) and director of the Israeli Origami Center, and relocated from London, England, to Israel. He has an MA in Fine Art from the Slade School of Fine Art, University of London.

Giang Dinh, Vietnam

Giang Dinh was born in Vietnam in 1966 and began creating folded paper models in primary school. He later went on to study architecture in Vietnam and the United States. Today he lives as an architect in Virginia.

"Figures," 2003

Each folded out of one square piece of uncut watercolor paper, the two models belong to a series of abstract figures depicting martial fighters and graceful dancers.

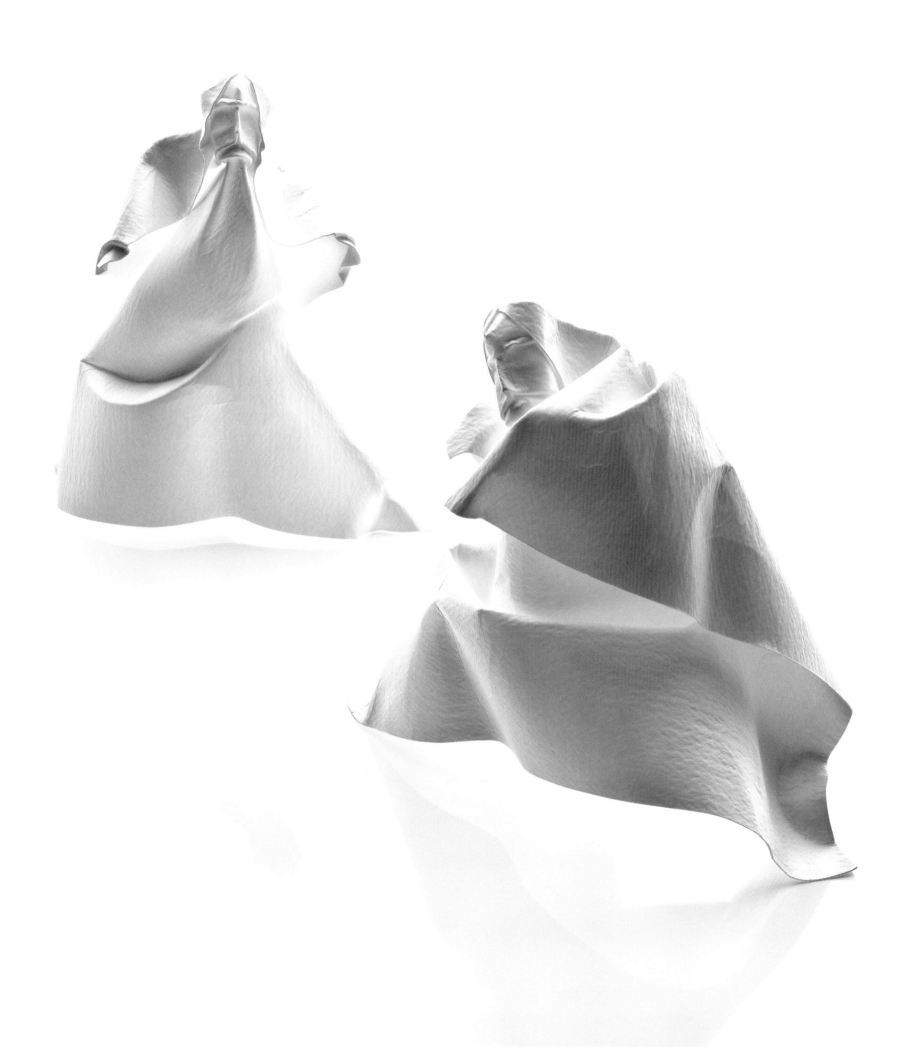

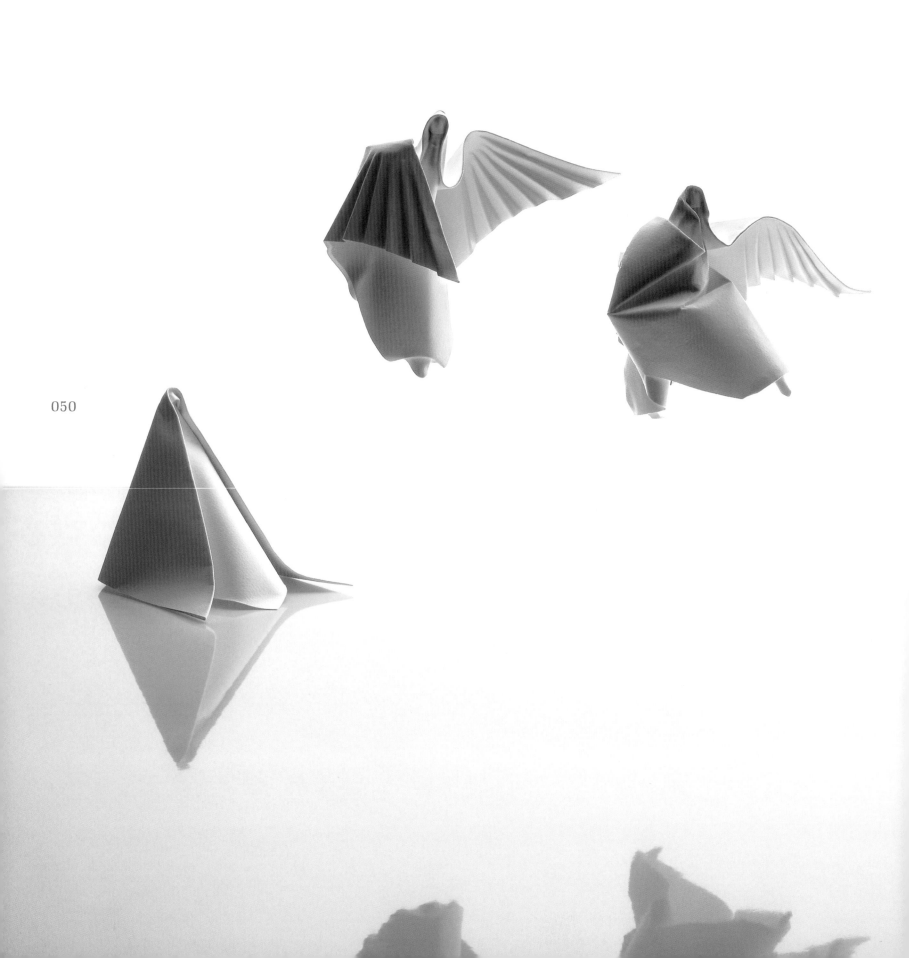

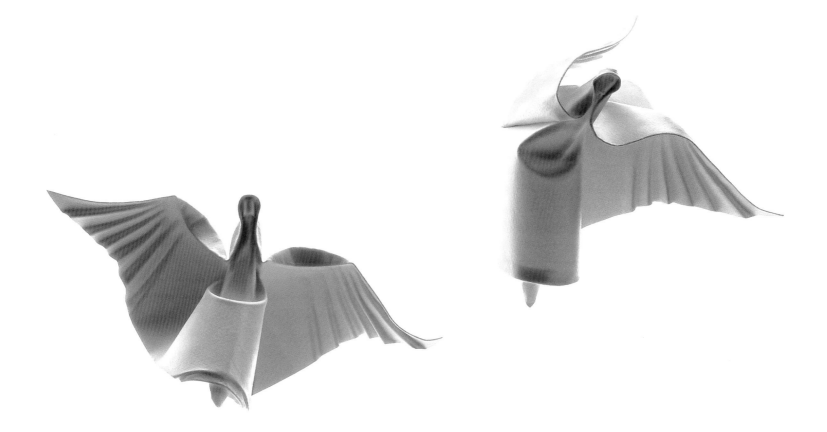

"I Want To Fly," 2005

Each folded out of a square piece of uncut printing paper, the five models belong to a series symbolizing the dream of flying.

Saburo Kase, Tokyo, Japan

When Saburo Kase lost his eyesight at the age of twelve, he already had
some experience folding simple paper models. In spite of his handicap,
he perfected his folding skills over the next fifty years. The physical
and mental power of sumo wrestlers whom he had encountered when
he could still see as a child became Saburo Kase's guiding principle:
"The memory gave me the power to master my life like a 'flying bull'."

"Sumo Dream," April 2005

The Yokozuna champions of sumo wrestling embody the spirit of power
and dignity inherent in Japan's national sport. The sculpture was created
by folding several sheets of washi paper.

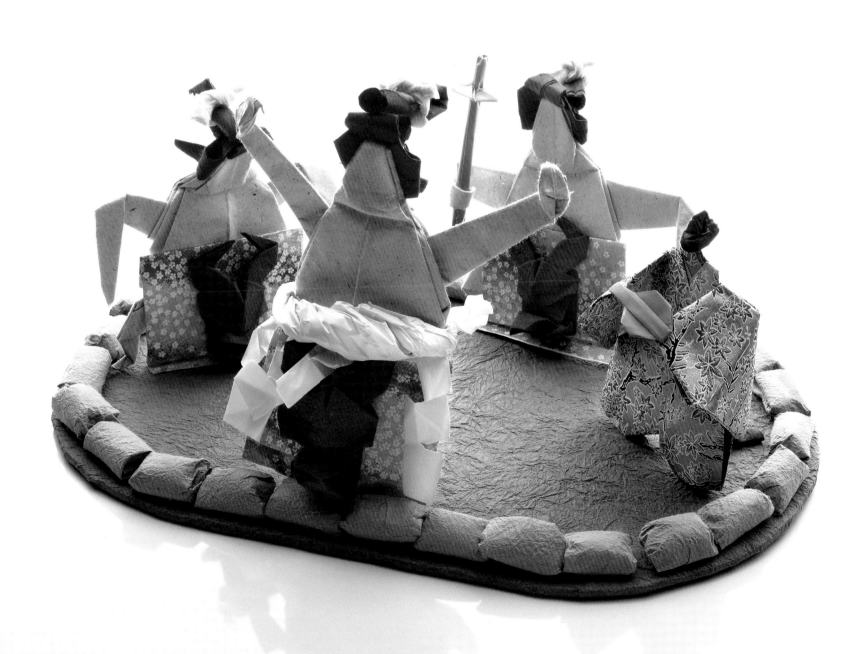

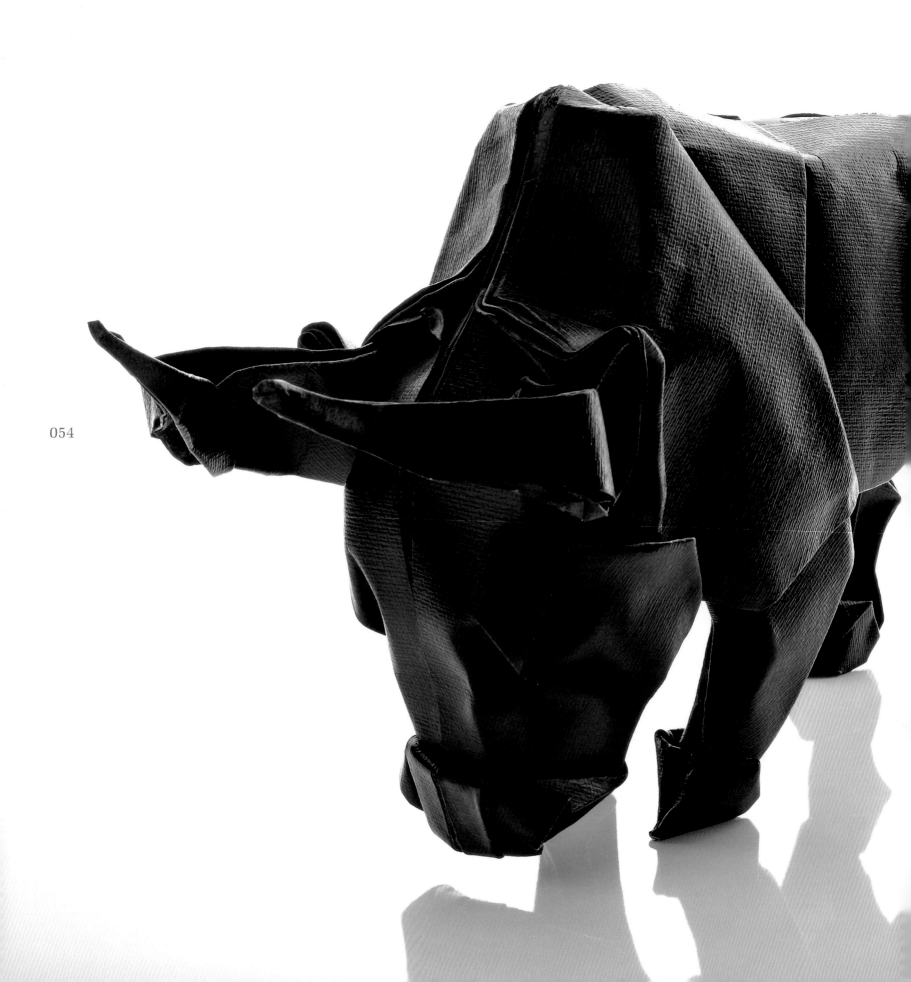

054

Stefan Weber, Cologne, Germany

Stean Weber was born in 1963 in Cologne.
He lives in Chile and Germany as an origami artist
and instructor of classical guitar. Stefan Weber has
been folding origami models for ten years.

"Bull," 2005

Folded from watercolor paper

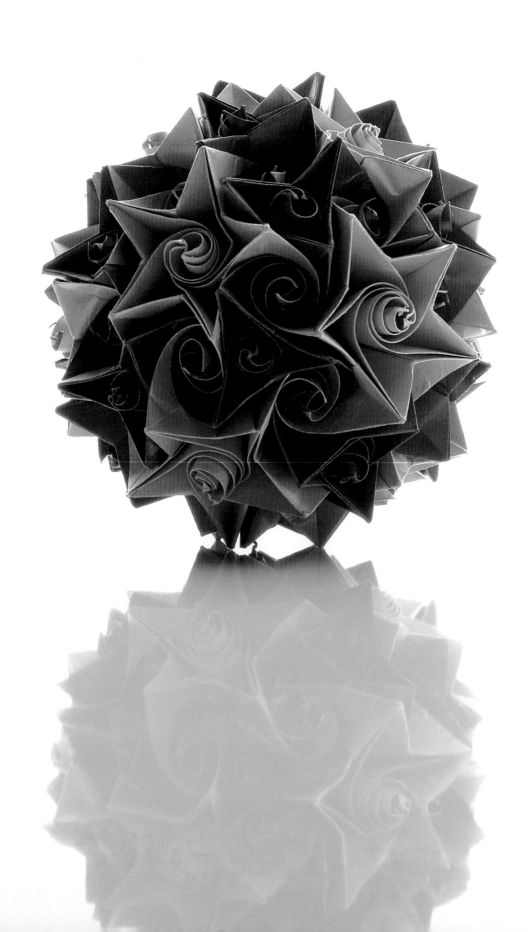

Krystyna Burczyk, Wojtek Burczyk, Krakow, Poland

Both Krystyna and Wojtek Burczyk studied theoretical mathematics. In 1997, their attention was directed to Jim Plank's origami page on the internet. Ever since, they have been creating folded paper models which they let evolve step by step like a geometrical construction. In 2000, Krystyna and Wojtek Burczyk founded the Polish Origami Center in Krakow.

"Space Series," March, April 2005

The three models in Space Series symbolize the planet of Mars (left) and Venus (right) as well as the Mars moon Phobos (center). The models were folded using the modular technique of origami. They consist of 48–120 individual pieces that have been fitted together without any glue.

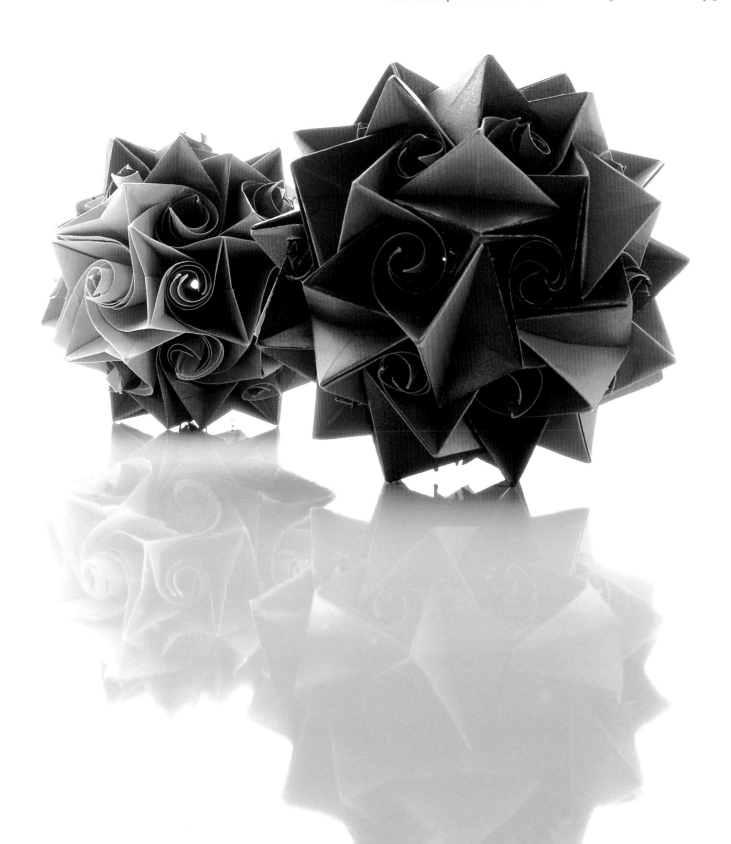

Rona Gurkewitz, Bennett Arnstein, USA

Rona Gurkewitz lives in Brookfield, Connecticut, and is professor for computer science at Western Connecticut State University. Bennett Arnstein lives in Los Angeles and teaches origami in southern California.

"Gyroscoped Rhombicuboctahedron," "Gyroscoped Truncated Cube," "Gyroscoped Snub Dodecahedron," 2000, (clockwise from top)

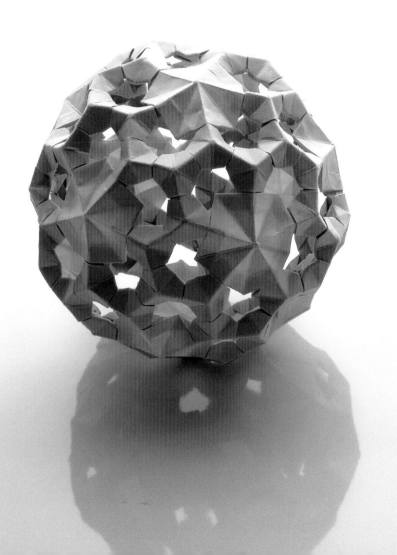
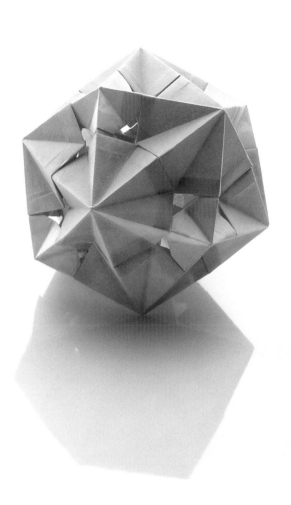

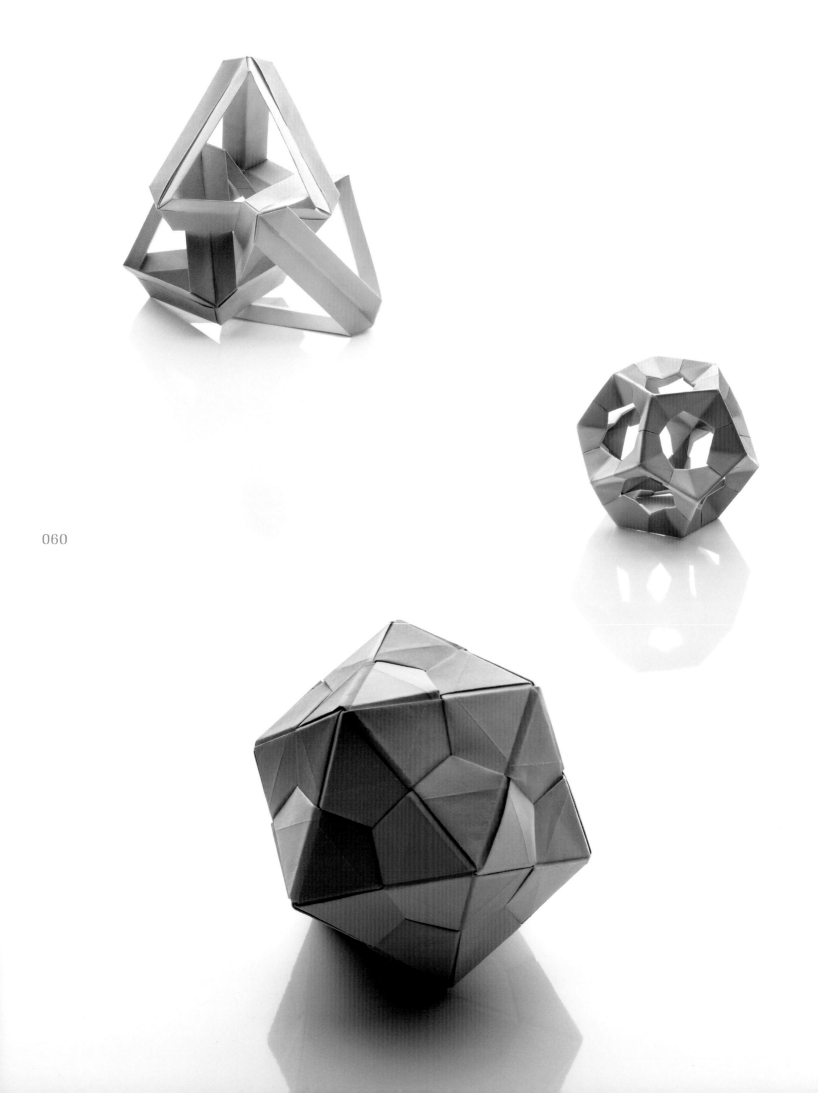

"Wreath of 3 Linked Tetrahedrons"

made from 18 modules, which were originally created by
Ian Harrison, **"Dodecahedron"** from 20 one-piece triangle modules,
"Icosahedron" from 10 triangle edge modules. (clockwise from top)

The incredibly complex sculptures made of various polygons
illustrate the close link between origami and geometry in a
compelling way. The folded models are each created out
of several sheets of pastel packaging paper.

David Brill, Poynton, England

David Brill began creating origami models as a child in the nineteen-fifties. Today he is the vice-president of the British Origami Society.

"Peaseblossom," 2003

Folded out an uncut, square sheet of watercolor paper without the use of scissors or glue.

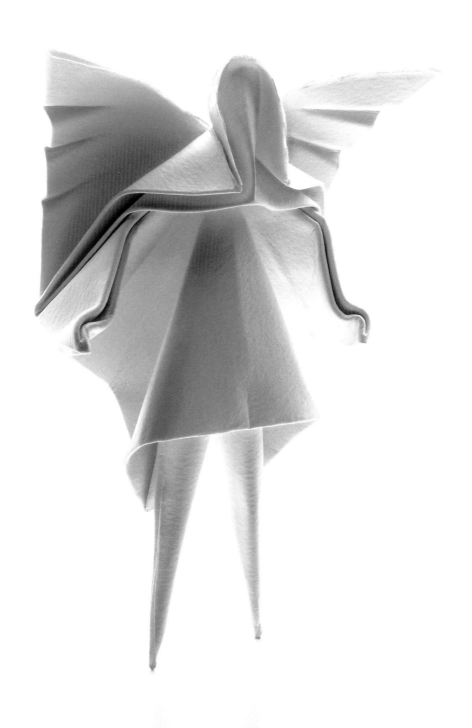

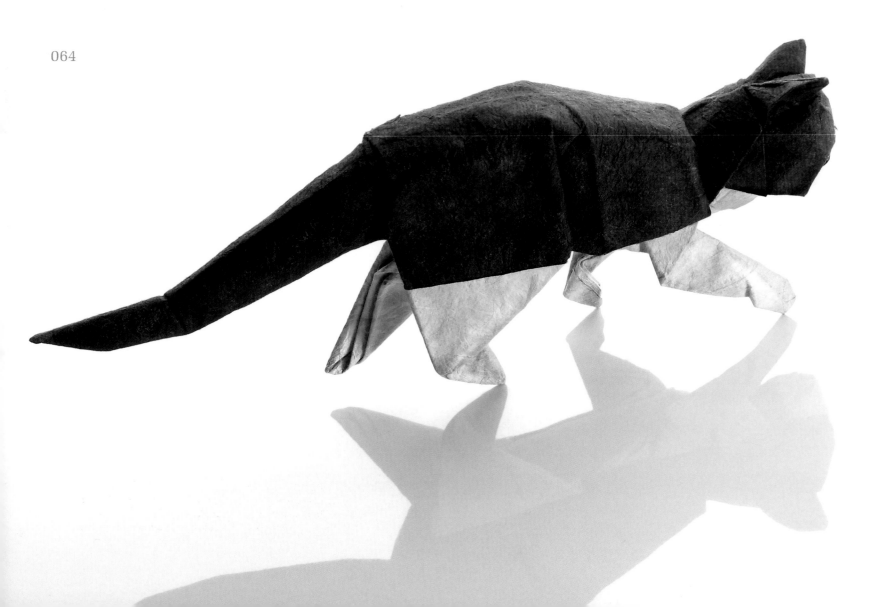

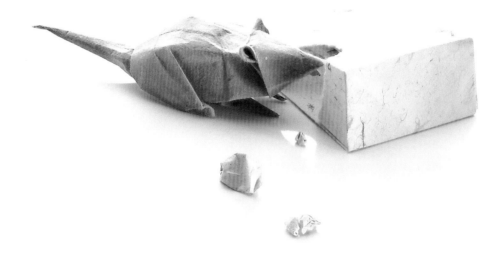

"Cat, Mouse and Cheese," 2002

The cat was folded out of an uncut, square sheet
of black and white momigami paper. The mouse and
cheese were each cut out of a sheet of hand-made
Michael LaFosse paper. All models were created
without the use of scissors or glue.

"Rotating Double Cube Series,"
designed 1993, folded 2005

Each of the nine elements was folded out of twelve
different-sized sheets of paper in square format.

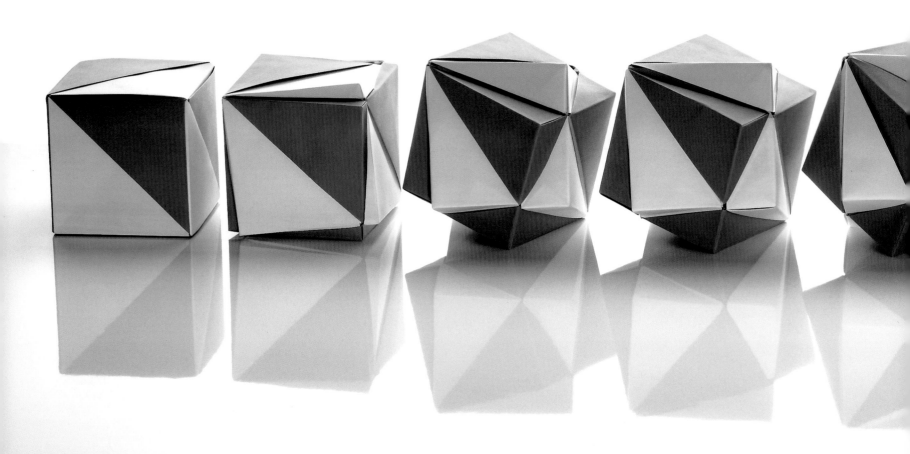

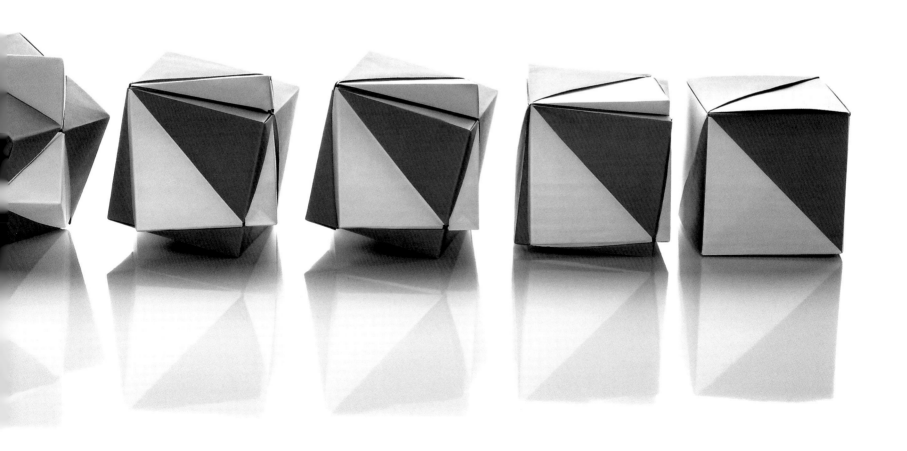

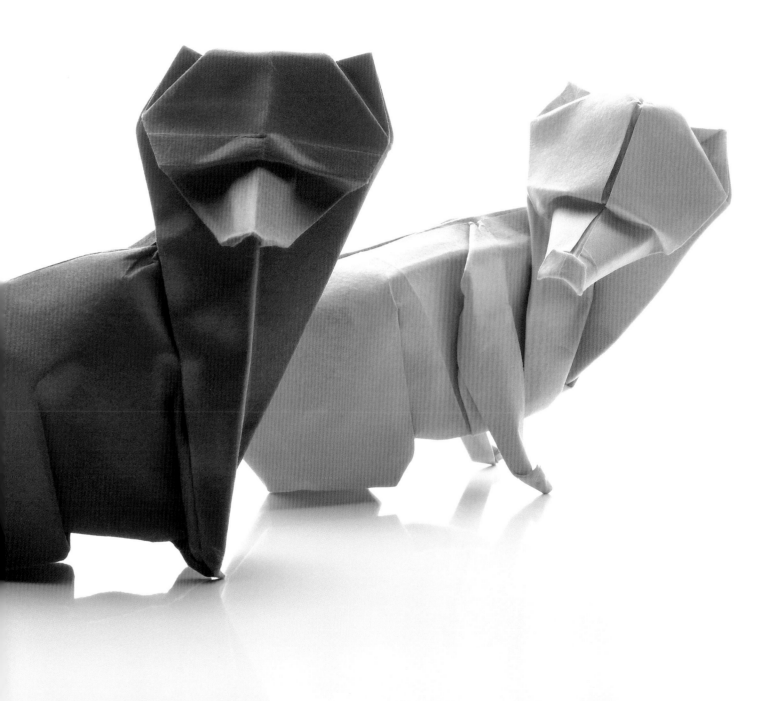

(Page 68) **"Fox Couple,"** 1988

(Page 70) **"Insects," "Scorpions," "Crabs,"** 1987

Alfredo Giunta, Sicily, Italy
Born in the small village of Roccalumera on the island of
Sicily in 1950, Alfredo Giunta attended the Arts College in Mes-
sina. Today he lives and works as a teacher of art in Vicenza.

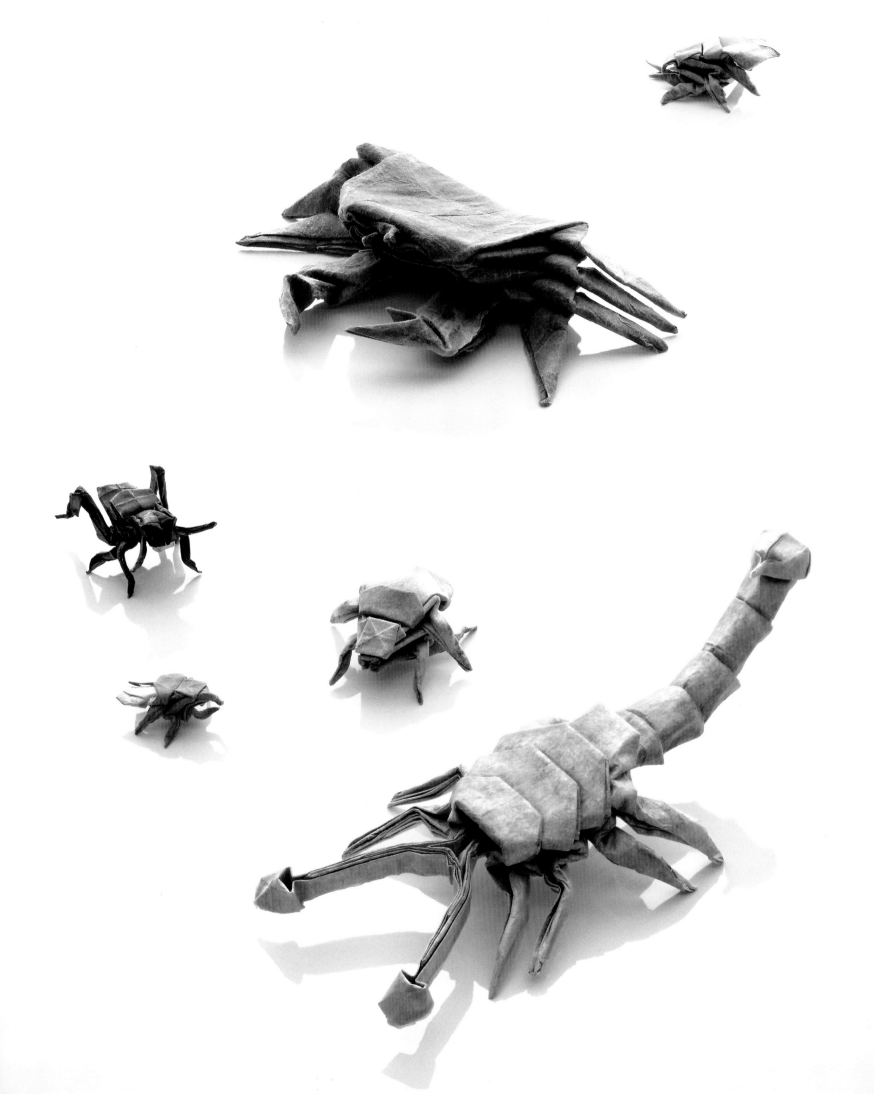

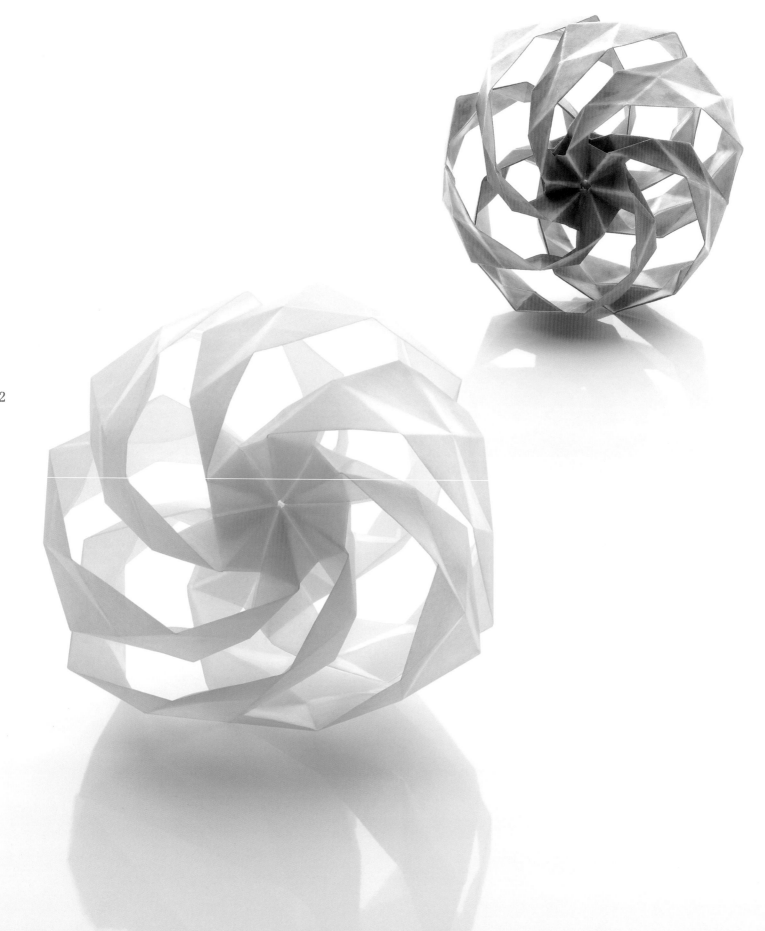

072

Toshikashu Kawasaki, Japan

"Seeds in the Wind," February 2005

The models consist of 6 pieces of rectangular paper.
No use of scissors or adhesive.

Jun Maekawa, Tokyo, Japan

Jun Maekawa was born in Tokyo in 1958. Having studied physics, he developed a new origami method based on fundamental geometric patterns that mark the beginning of "complex origami." Maekawa's insights into the connection of mathematics and origami are summed up in the "Maekawa Theorem."

"I Want To Fly. Know Impossibility. But, Wish Innovation (KIWI)," concept 1984, model 2005

The model is made of Japanese washi paper which was tinted yellow and brown. A square sheet of paper measuring fourteen centimeters on the sides was folded without the use of scissors or adhesive.

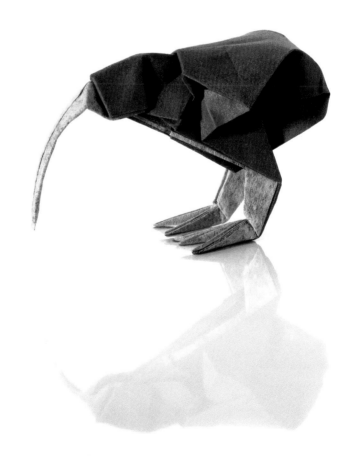

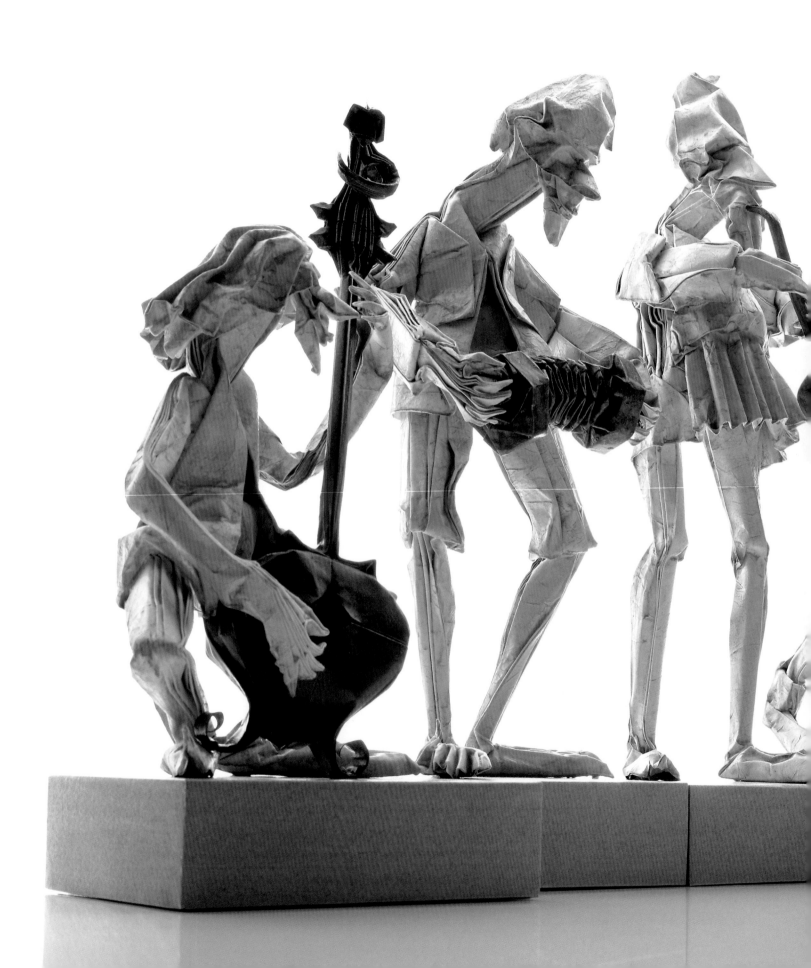

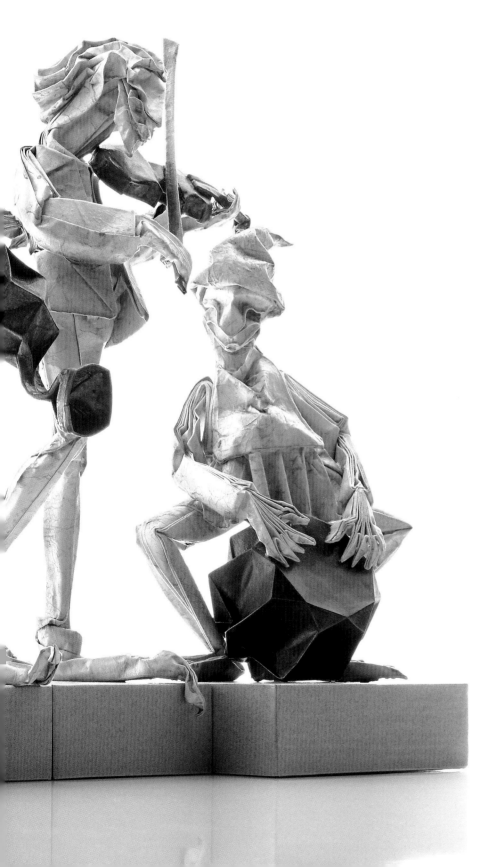

Eric Joisel, Paris, France

Eric Joisel began creating folded paper models in 1983 and has been living in Paris since 1991 as a professional origami artist. Inspired by Akira Yoshizawa's work, it is Joisel's main interest to give his figures "a breath of life."

"Faerie's Orchestra," 2004

A square sheet of paper measuring 60 centimeters on each side was used for each musician. Square and rectangular sheets of paper were used for the instruments. The uncut foil paper was folded in a sandwich form and then treated with acrylic.

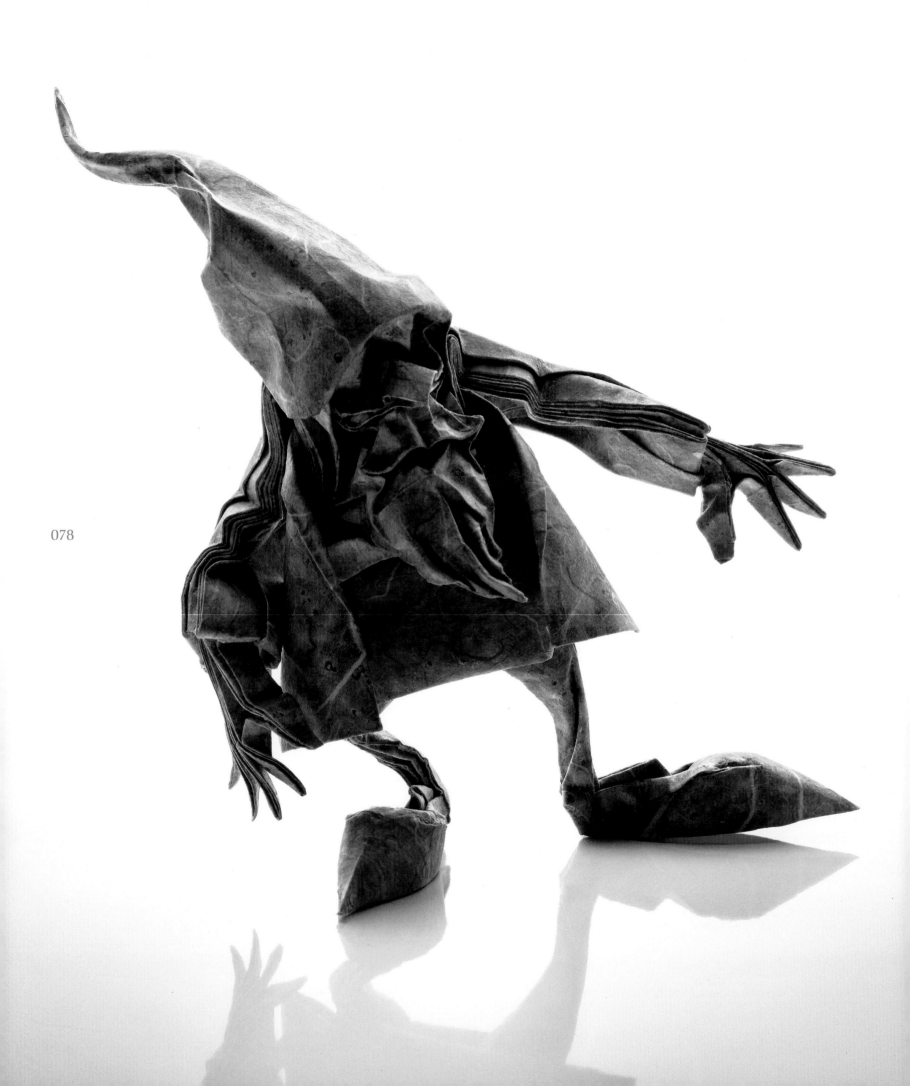

078

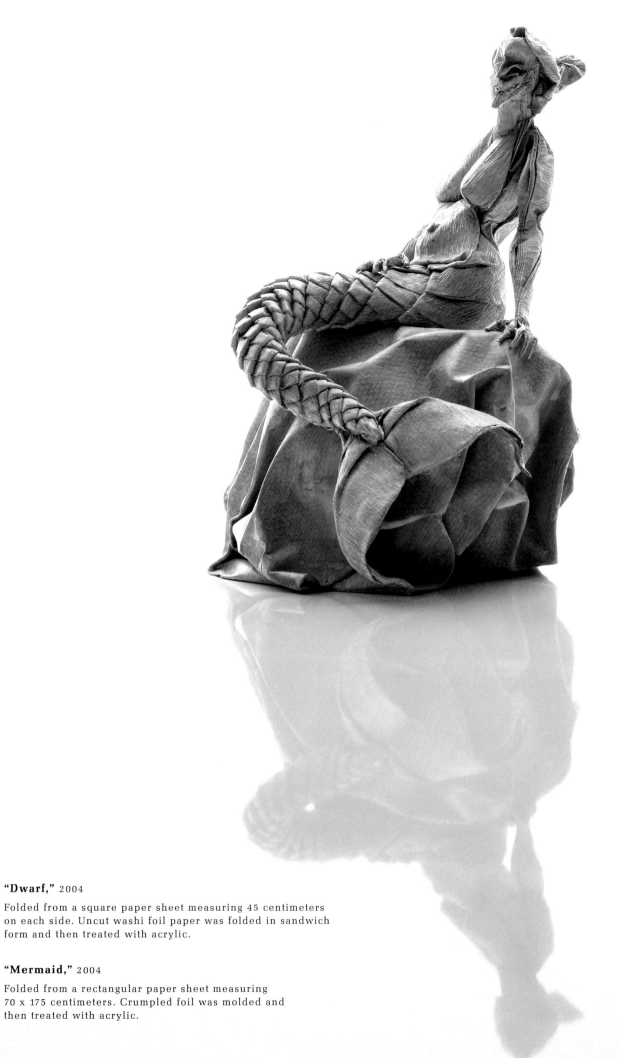

"Dwarf," 2004

Folded from a square paper sheet measuring 45 centimeters on each side. Uncut washi foil paper was folded in sandwich form and then treated with acrylic.

"Mermaid," 2004

Folded from a rectangular paper sheet measuring 70 x 175 centimeters. Crumpled foil was molded and then treated with acrylic.

Nathan M. Geller, Philadelphia, USA

Nathan M. Geller began folding origami when he was eight years old and for the last 12 years he is creating his own designs. Among other things, he has taught at the Origami USA Congress in New York.

"Coming Around The Mountain," March 2005

The aircraft was folded from a square sheet of laminated paper without the use of scissors or adhesive.

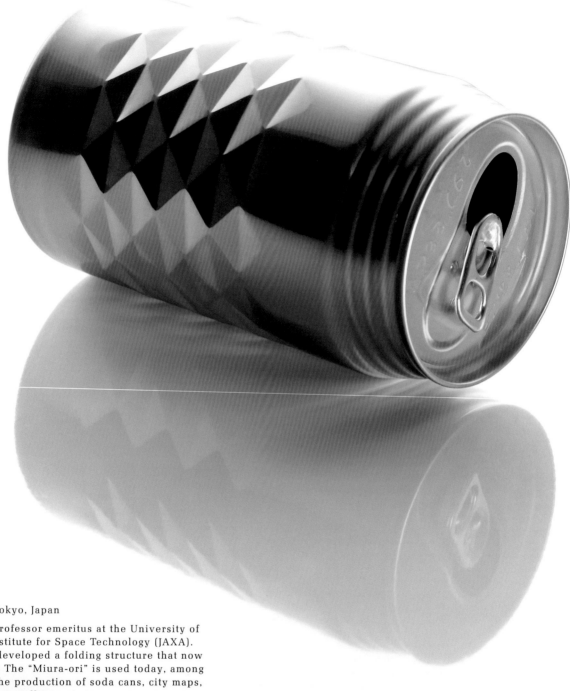

082

Koryu Miura, Tokyo, Japan

Koryu Miura is professor emeritus at the University of
Tokyo and the Institute for Space Technology (JAXA).
In the 1970s, he developed a folding structure that now
carries his name. The "Miura-ori" is used today, among
other things, in the production of soda cans, city maps,
and solar sails for satellites.

"PCCP Origami Can," design 1970, production 1995

The wall of an aluminum can was folded into a many-sided
pattern. The increased stiffness significantly reduces the
need of material.

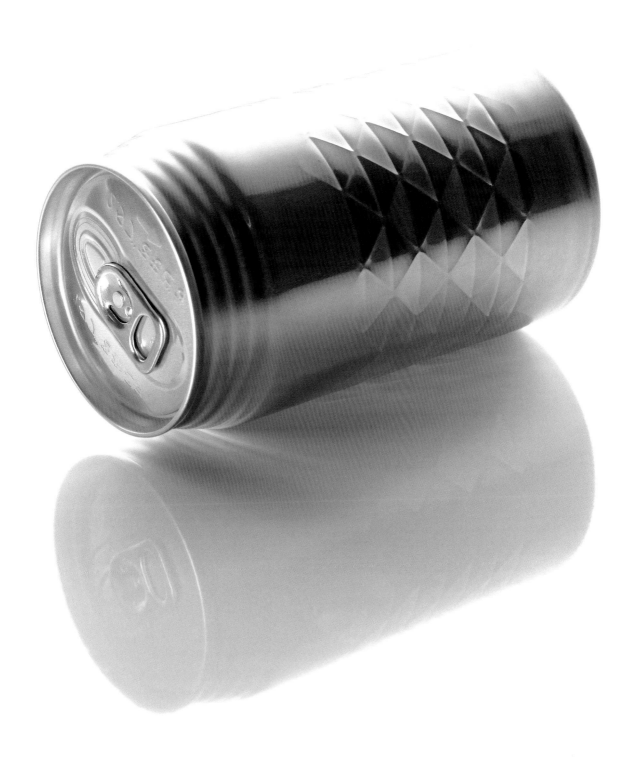

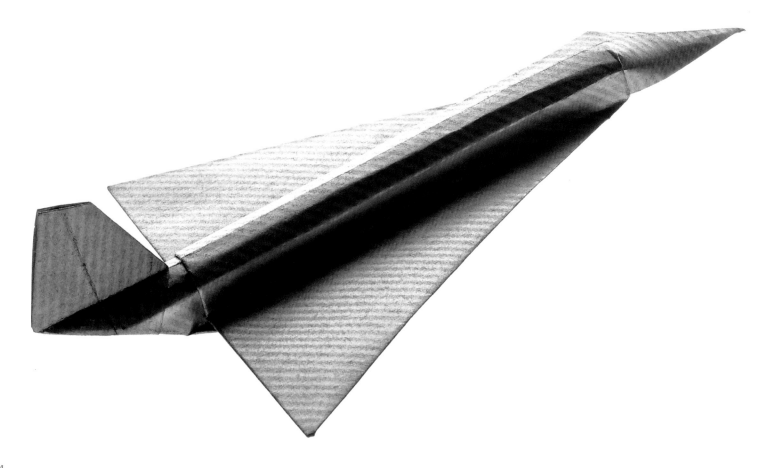

084

Nick Robinson, Sheffield, England

Nick Robinson has been folding paper models since the early eighties. He is a member of the British Origami Society, publisher of their magazine, and their web designer: www.britishorigami.org.uk

"Concorde," 1992

Folded from a square sheet of origami paper without the use of scissors or adhesive.

Hideo Komatsu, Japan

Hideo Komatsu was born in 1977 and is presently
a member of the Japan Origami Academic Society.

"Owl," 1997

The model was folded from a square sheet of
paper without the use of scissors or adhesive.

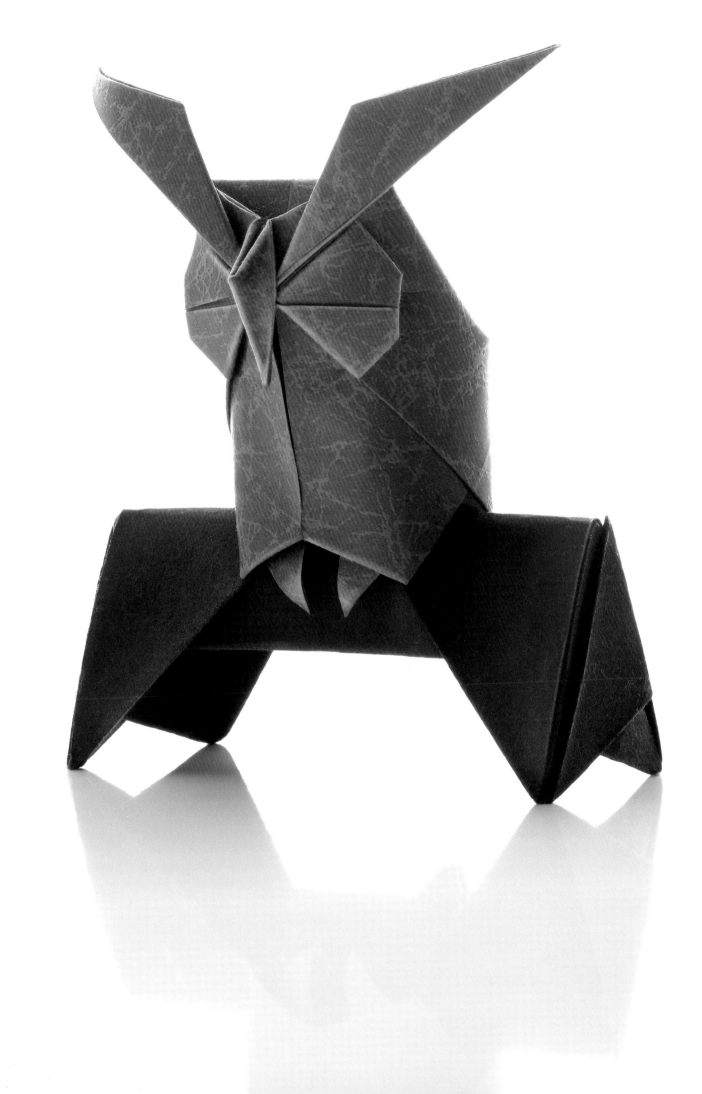

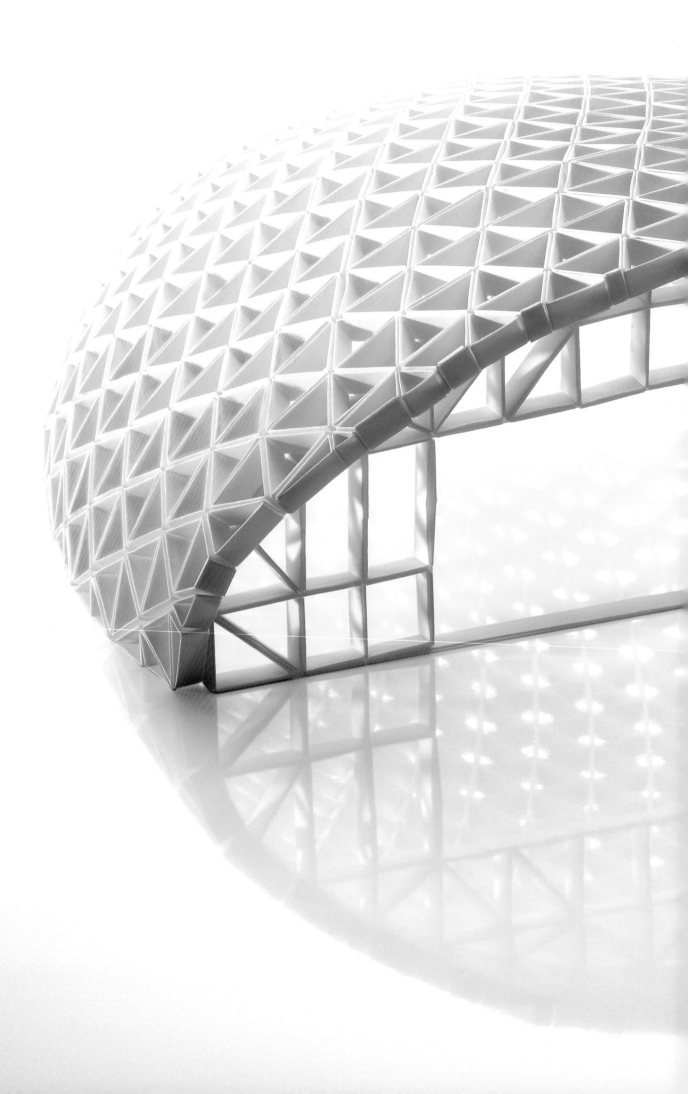

088

Heinz Strobl, Germany

Heinz Strobl was born in Bavaria in 1946 and has
been folding origami models since kindergarten. He
studied physics at the Technical University in Munich.
Today he develops software for high-end computers
as his main profession. In 1992, Strobl discovered his
unique predilection for folding strips of paper and
developed the technique of "knotology."

"H-8," April 20–May 6, 2005

Short sections of telex strips are folded into triangles
and combined with even shorter sections. The approxi-
mately 2,500 individual pieces are square sections of
telex strip that are processed and connected without
further incisions or the use of adhesive.

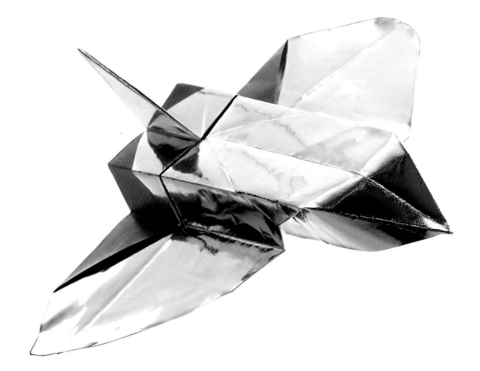

Dino Andreozzi, Italy

Dino Andreozzi was born in Italy in 1965 and folded
traditional origami models as a child. In 1988, he went to
Sweden and studied the works of the German pedagogue
and paper folder Friedrich Fröbel at Linköping University.
Today, Dino Andreozzi works as an origami teacher in Chile.

"FX Jetplane, Jet Airplane," 2005

Both models were constructed from a single, square
sheet of paper without the use of scissors or adhesive.

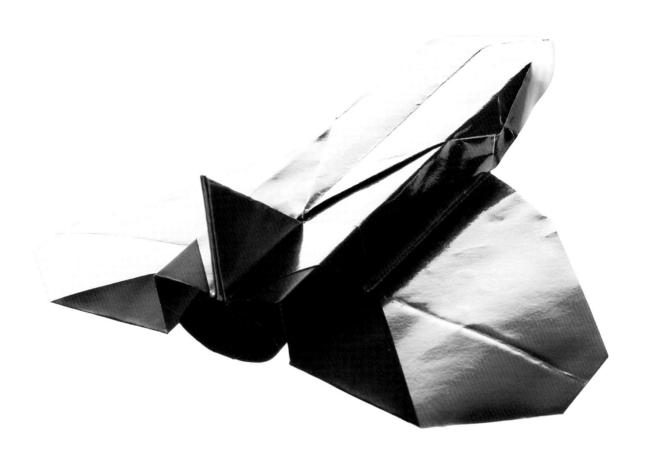

Hojyo Takashi, Tokyo

"The Victory of Samothrace," 2003

Folded from a square sheet of paper with a side length of
35 centimeters without the use of scissors or adhesive.

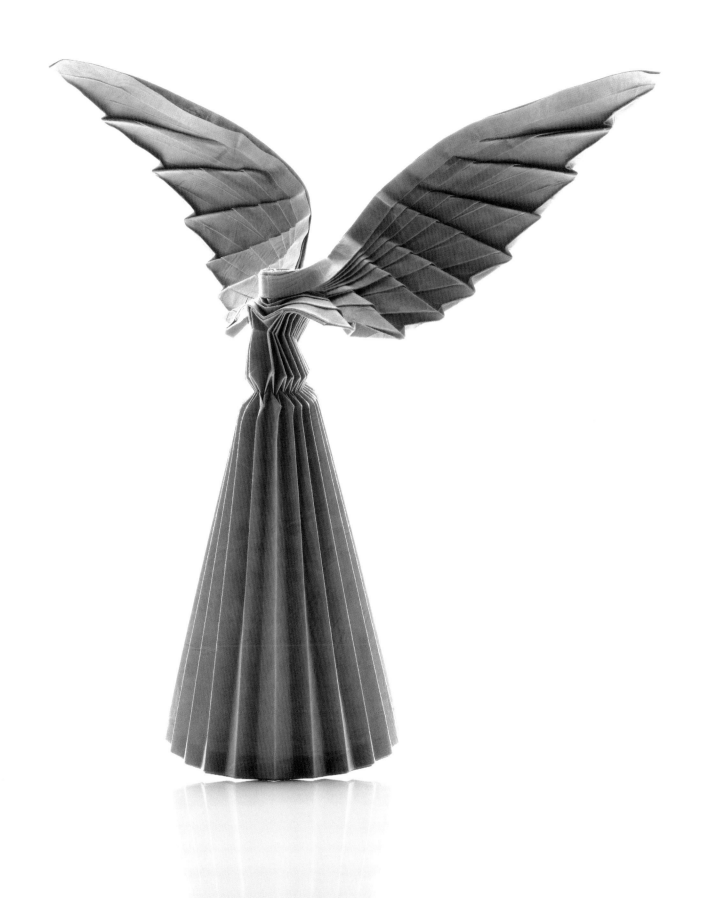

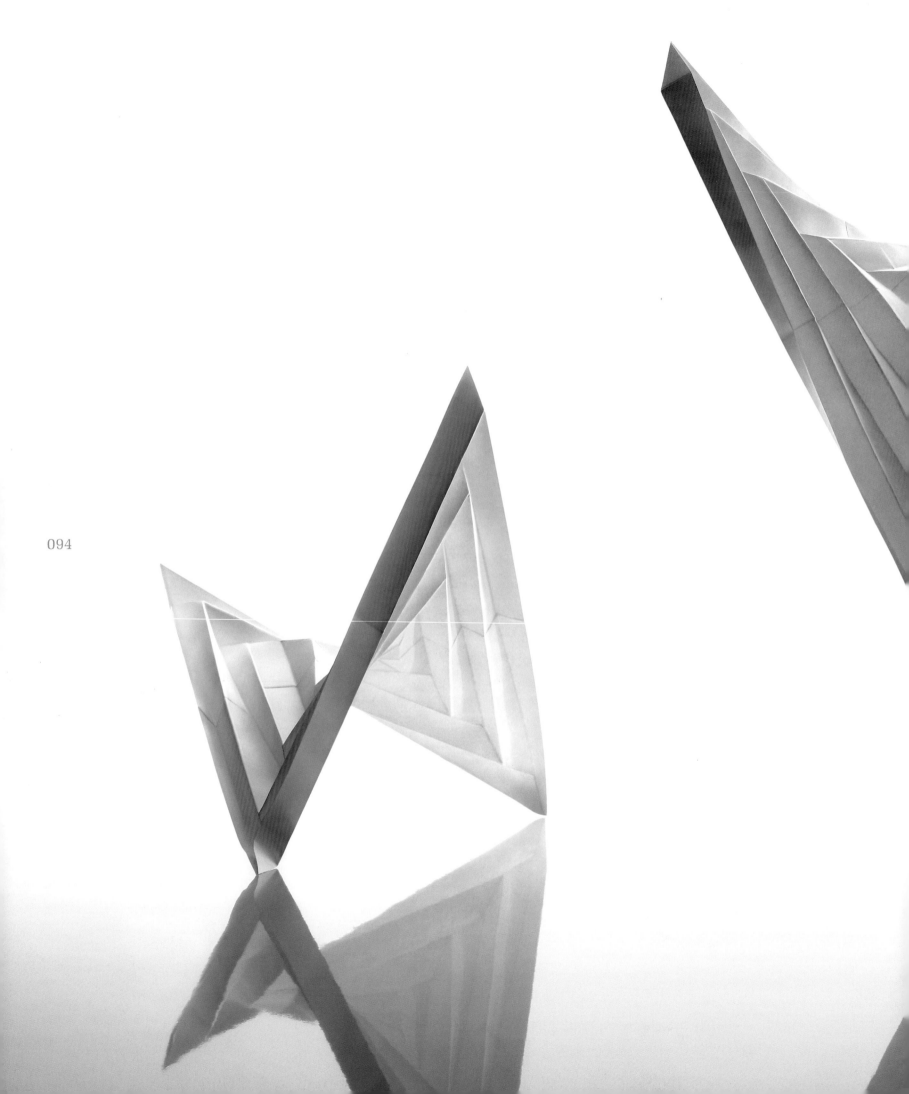

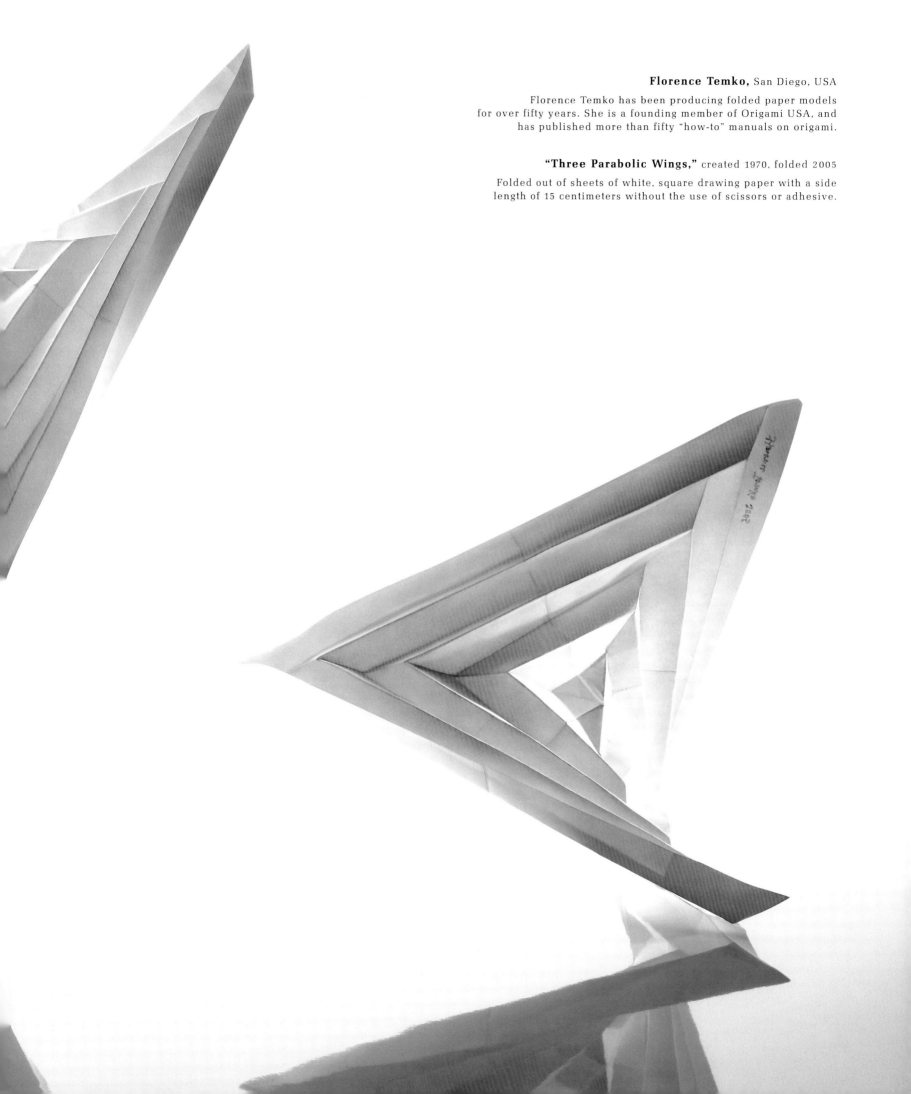

Florence Temko, San Diego, USA

Florence Temko has been producing folded paper models for over fifty years. She is a founding member of Origami USA, and has published more than fifty "how-to" manuals on origami.

"Three Parabolic Wings," created 1970, folded 2005

Folded out of sheets of white, square drawing paper with a side length of 15 centimeters without the use of scissors or adhesive.

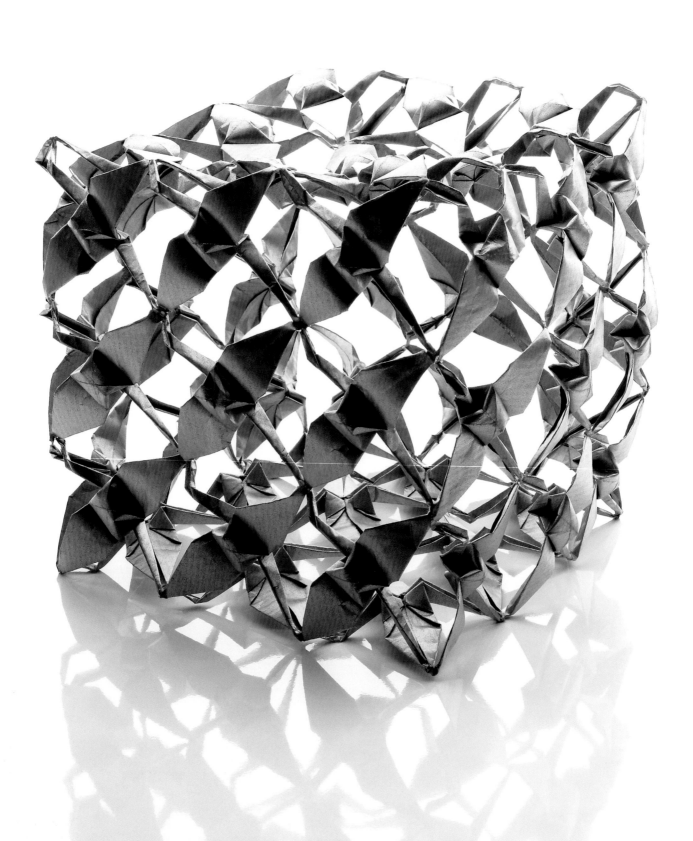

Linda Mihara, USA

Linda Mihara lives in San Francisco and has been folding paper
models since she was five. Today she is considered as a top
designer of the Sembazuru style (thousands of cranes) and has
won awards for origami based on the Rokoan technique.

"Crane Cube," May 2005

The cube of cranes was folded according to the so-called Rokoan technique
which here, in a most striking way, reaches into a third dimension.

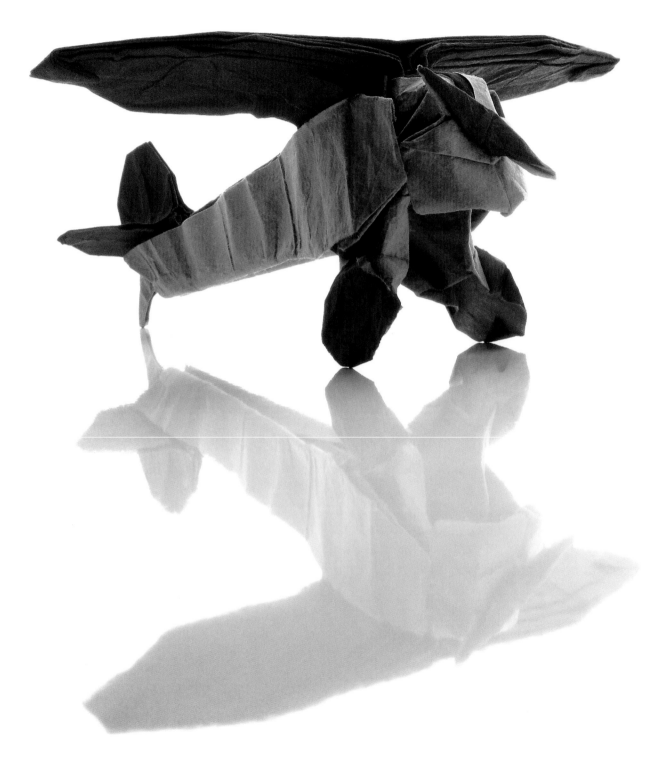

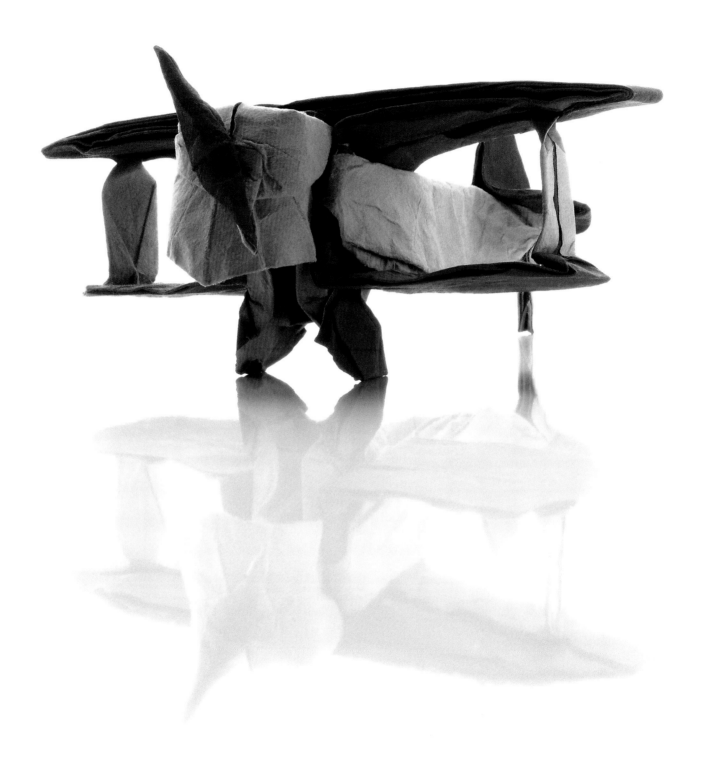

Marc Kirschenbaum, New York City, USA

Marc Kirschenbaum has been creating origami models for more than thirty years. He published the book "Paper in Harmony." Today he is a board member of Origami USA. As his main profession, Marc Kirschenbaum runs a consulting firm for information technology.

"Monoplane," 2002 **"Biplane II,"** 1996

The imaginative interpretations of classical plane models were created out of square sheets of paper consisting of red and yellow origami sheets that have been glued together.

Masashi Tanaka, Gifu Prefeecture, Japan

"Tanaka Butterfly," September 2004

Folded from a square sheet of paper with a side length of
38 centimeters without the use of scissors or adhesive

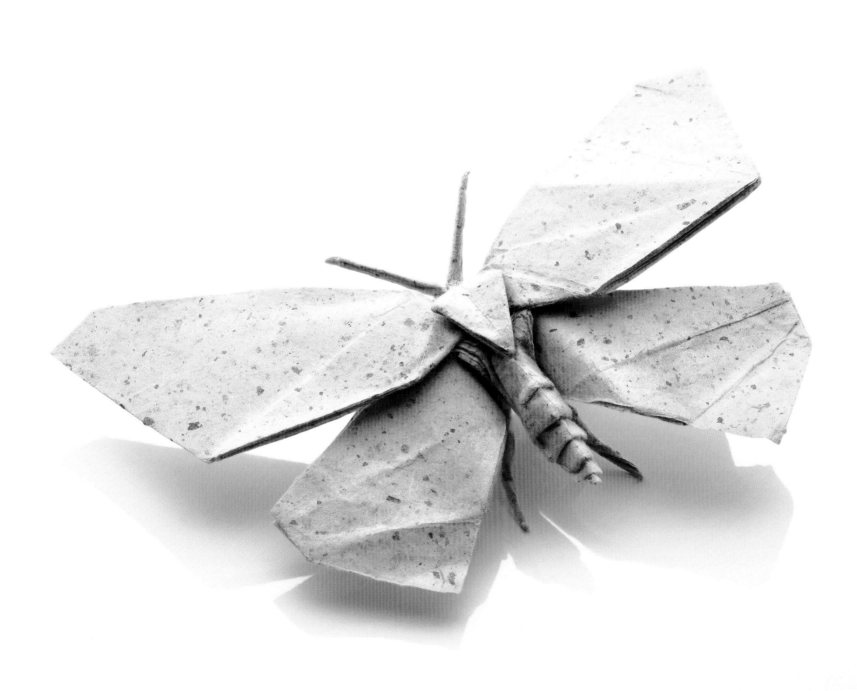

Mark Morden, Seattle, USA

Mark Morden was born in 1958 and learned origami in elementary school. Today he lives and works as an architect in Seattle where he founded the "Puget Area Paper-folding Enthusiasts Roundtable" (PAPER).

"Flower Bud Tesselation," 2004

Hand-made origami paper by Michael LaFosse was used for the dark background and Wyndstone paper for the flower mosaic. The mosaic was folded out of a single sheet of uncut paper.

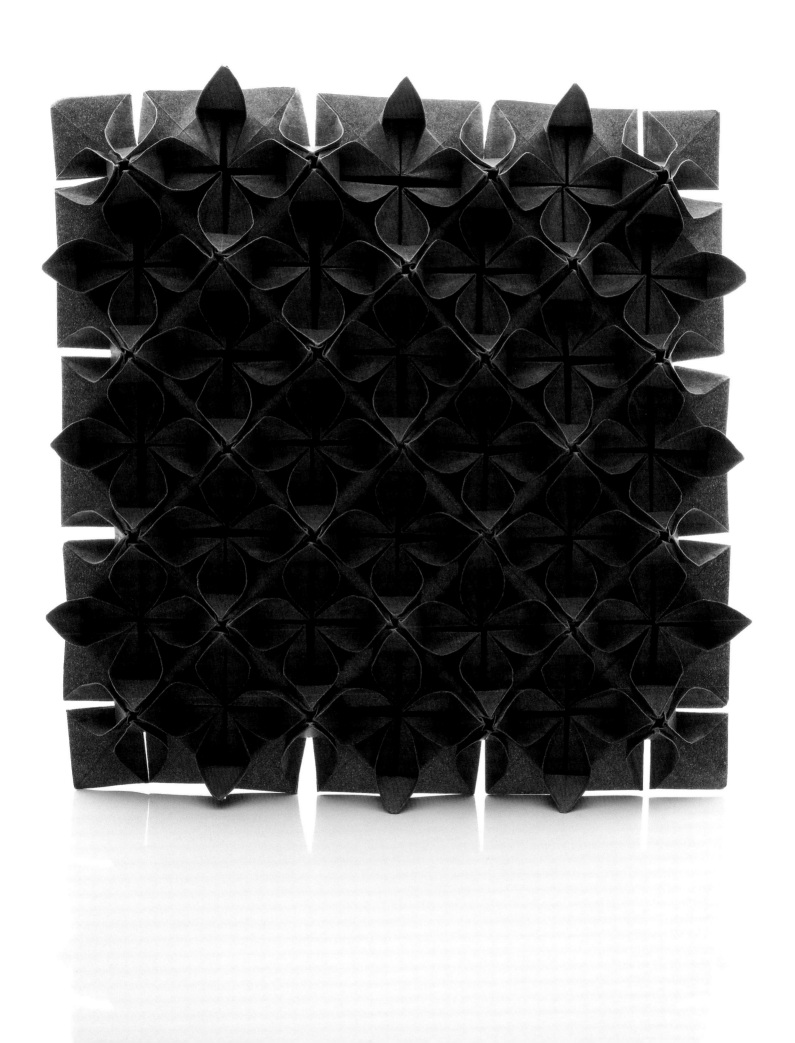

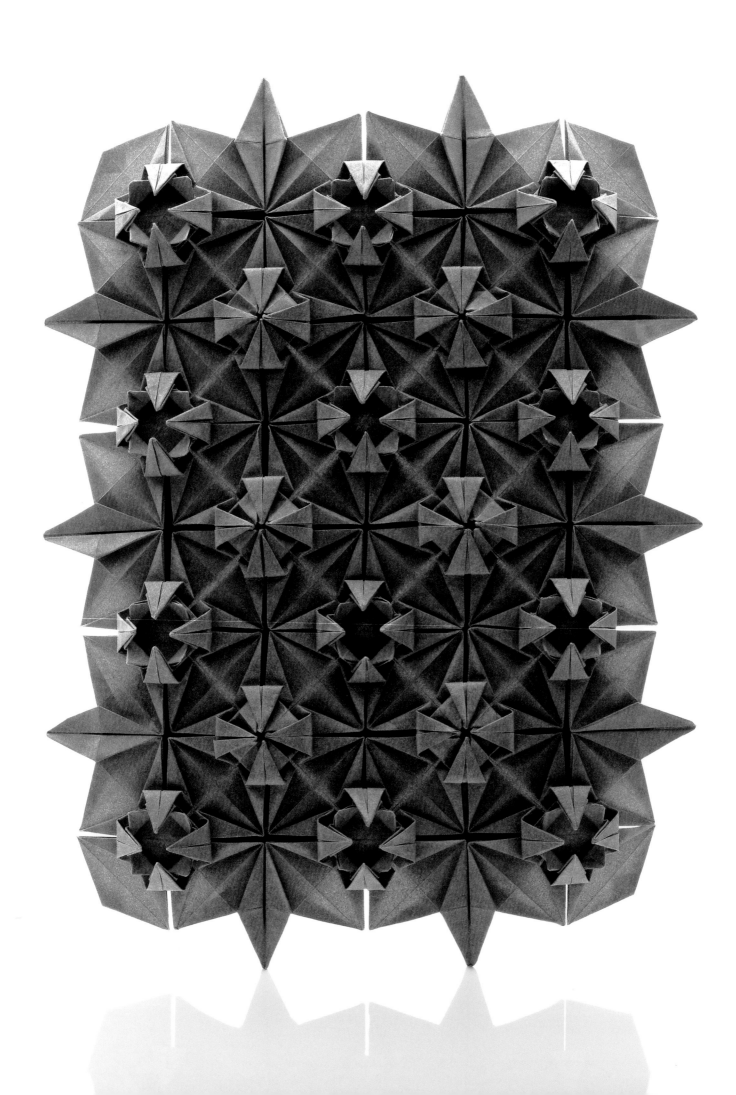

"Buttons and Bursts Tessellation," 2004

For this work, folded out of a single uncut sheet, grey
Wyndstone paper was used. Gold backing paper was
placed in the pockets on the reverse side so as to
heighten the visual contrast.

106

"Boucles, Pointes et Rondes Roses," March 2003

Folded from a square sheet of paper, colored
with ink and watercolors.

Jean Claude Correia, Casablanca, Marokko

Jean Claude Correia attended the École des Arts
Decoratifs in Paris and founded the Mouvement
Francais des Plieurs de Papier in 1978.

"Anne G," created 1990, folded 2004

From a square sheet of paper, tinted with
pigments and graphite, bound with acrylic.

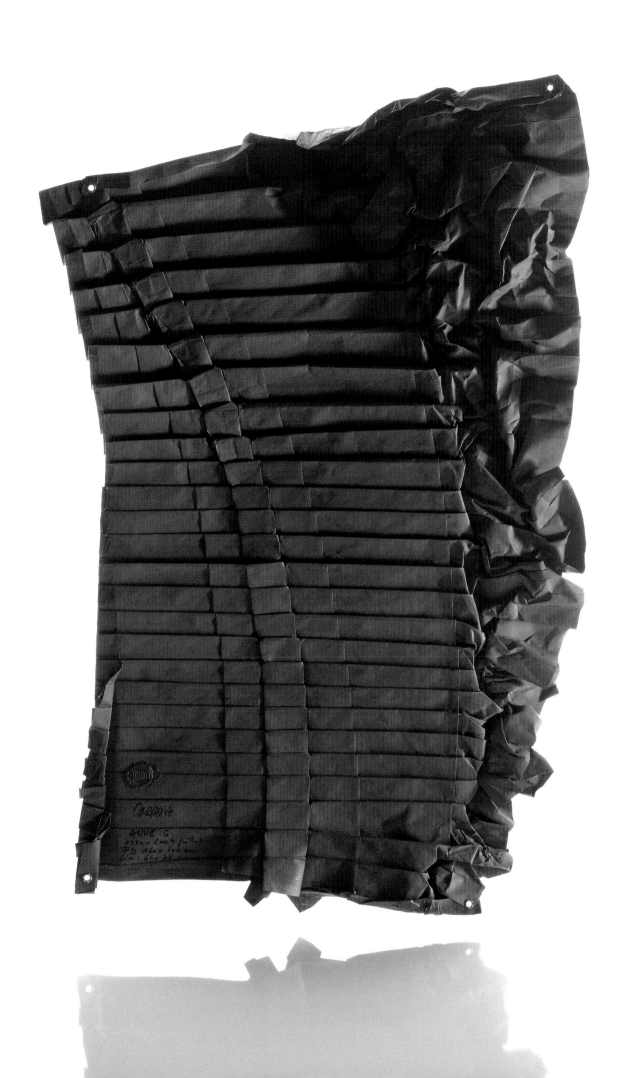

"Aïr," created 1989, folded 2004

From a square sheet of paper, tinted with
pigments and graphite, bound with acrylic.

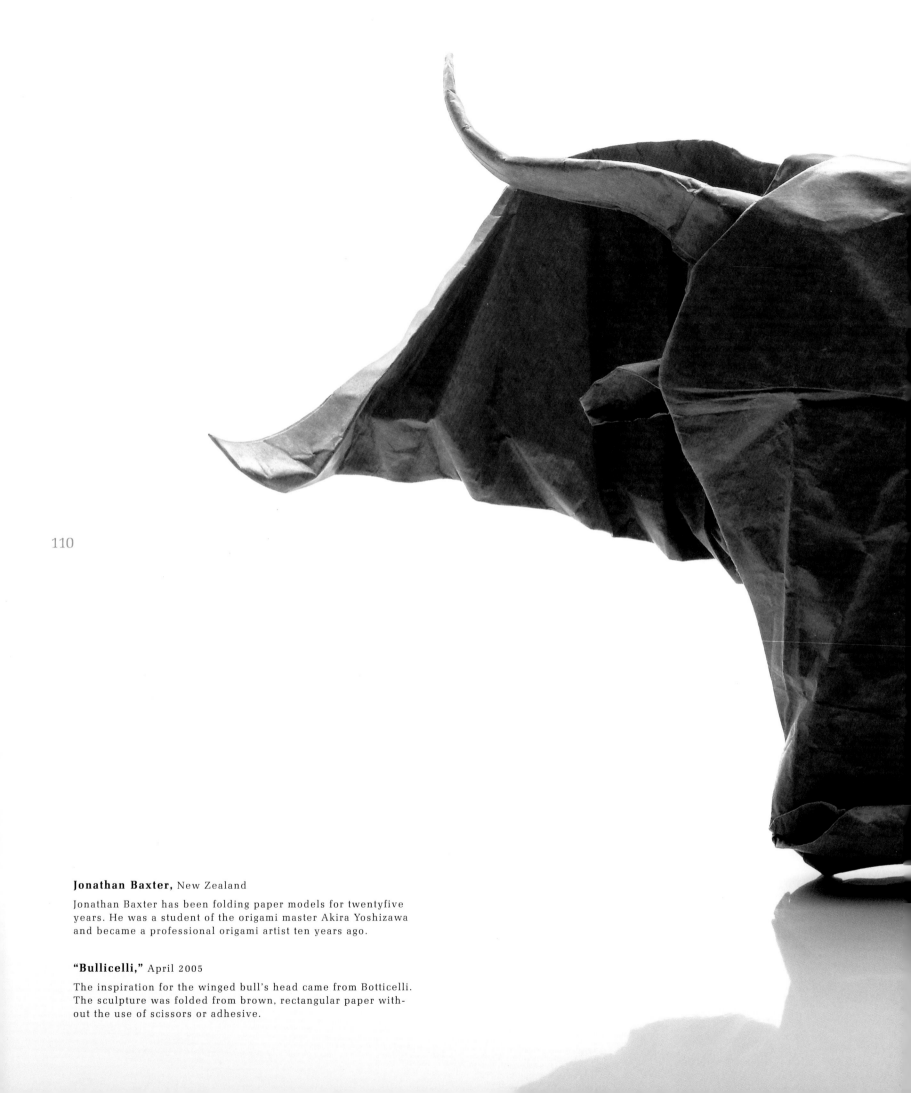

110

Jonathan Baxter, New Zealand

Jonathan Baxter has been folding paper models for twentyfive years. He was a student of the origami master Akira Yoshizawa and became a professional origami artist ten years ago.

"Bullicelli," April 2005

The inspiration for the winged bull's head came from Botticelli. The sculpture was folded from brown, rectangular paper without the use of scissors or adhesive.

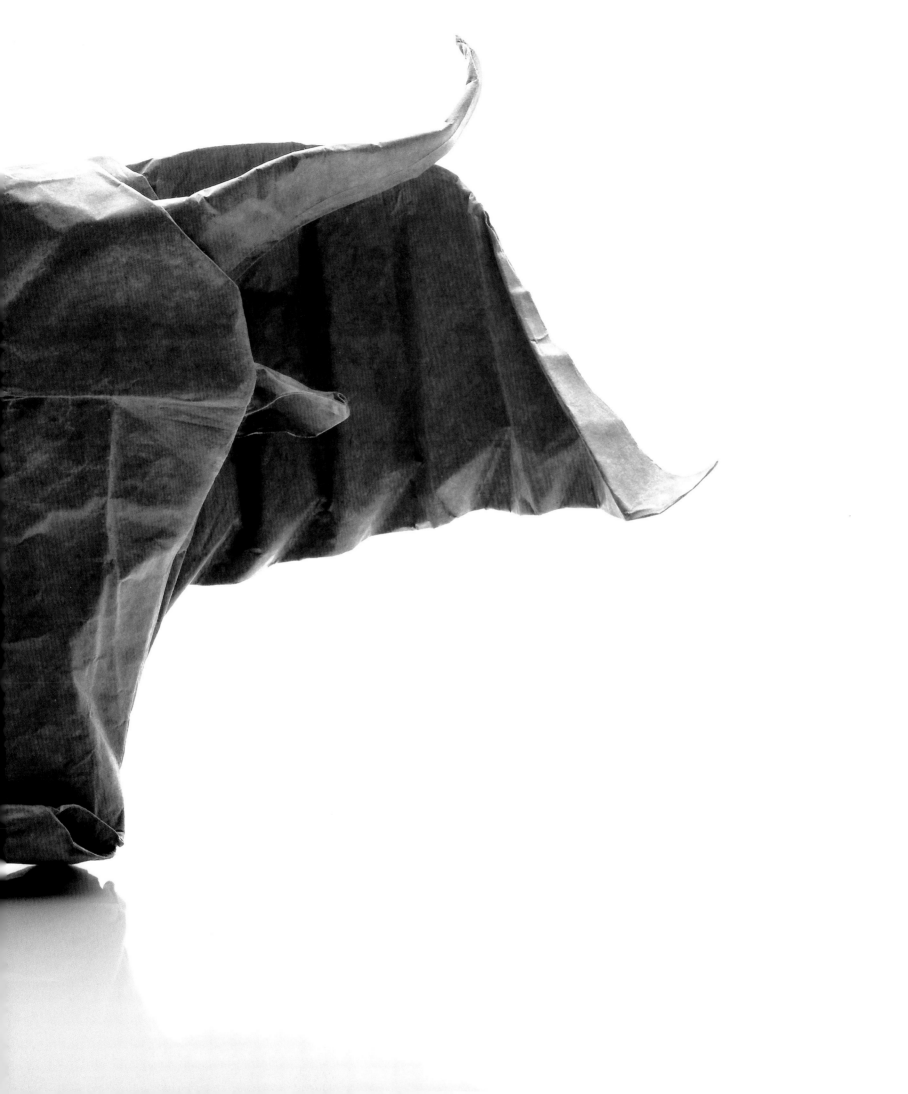

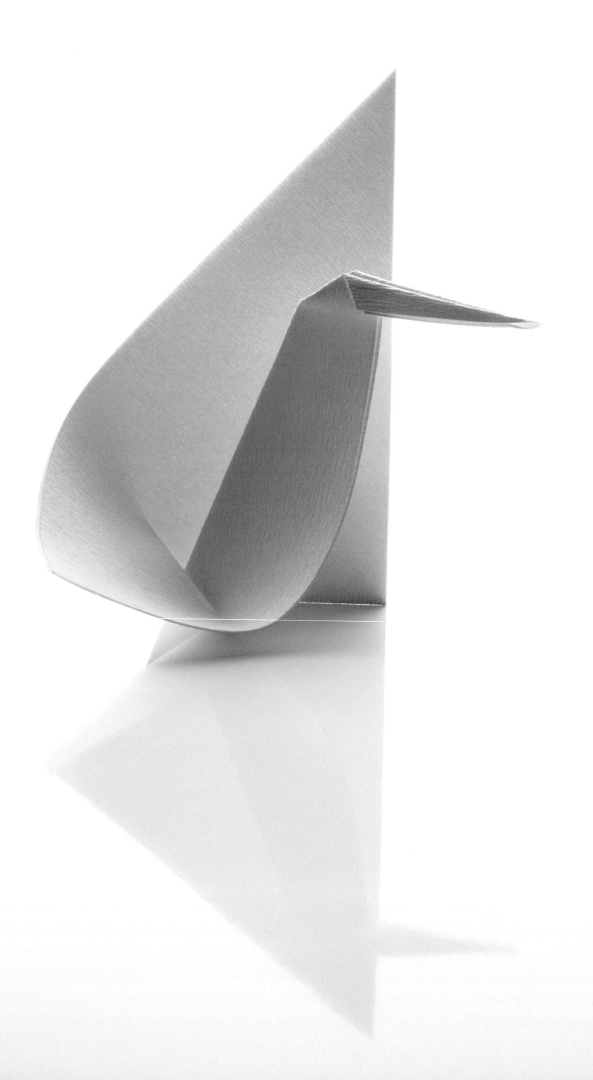

Paulo Mulatinho, Natal, Brazil

Paulo Mulatinho studied graphic and industrial design in Rio de Janeiro. He has been folding origami for twenty years and lives in Freising by Munich since 1985. Paulo Mulatinho is the founding president of Origami Germany.

"Planta," 2003

A black bird, which regularly visited Paulo Mulatinho on his balcony, was the inspiration for this model.

Kawahata Fumiaki, Toyota, Aichi Prefecture, Japan

"An Angel Playing the Harp," June 2001

Folded from a square sheet of paper without
the use of scissors or adhesive

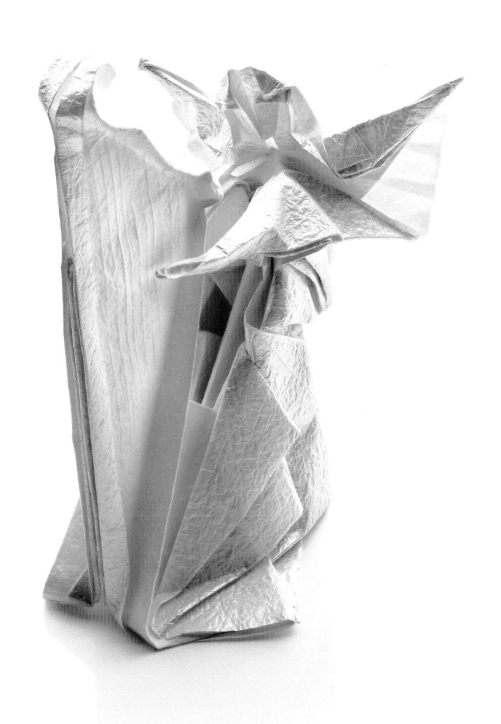

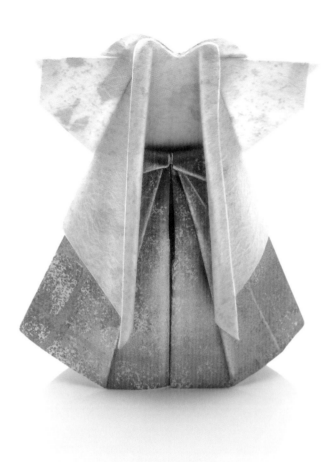

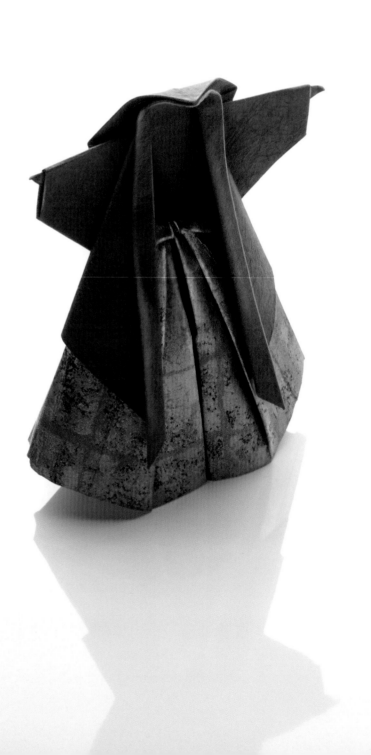

Makoto Yamaguchi, Tokyo, Japan

"Ren Jishi," created 1988, folded January 2005

Folded from two square sheets of paper respectively.

"Ren-Jishi" is one of the foundations of Kabuki, a traditional form of Japanese theatre. This "Lions' Dance" describes the harsh way in which the lion raises its cub: the parent pushes the cubs into the bottom of a ravine and then raises only the ones that manage to return to it. A red mane symbolizes the parent lion and white hair indicates a cub. The "lion" here is not the lion that we know but it is actually a shih tzu- here it's not the name of a dog but a legendary animal in ancient China. Thus the basis of the story is a very spiritual one.

Ruthanne Bessman, Madison, USA

Ruthanne Bessman has been folding origami for eighteen years and is an active member of Origami USA. One of her activities as an origami teacher is working with the children in the medical school hospital of the University of Wisconsin.

"Seikaiha–Cranes In Flight or Blue Ocean Wave," May 2005

The entire sculpture with nine cranes was folded from a single, square sheet of paper in which twelve cuts had been made.

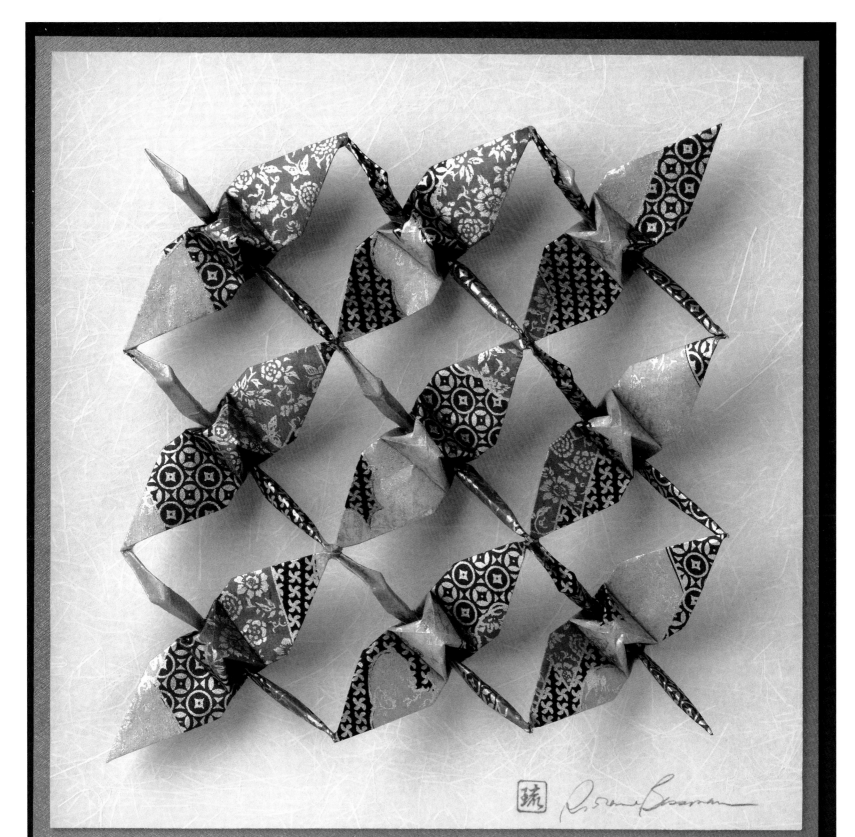

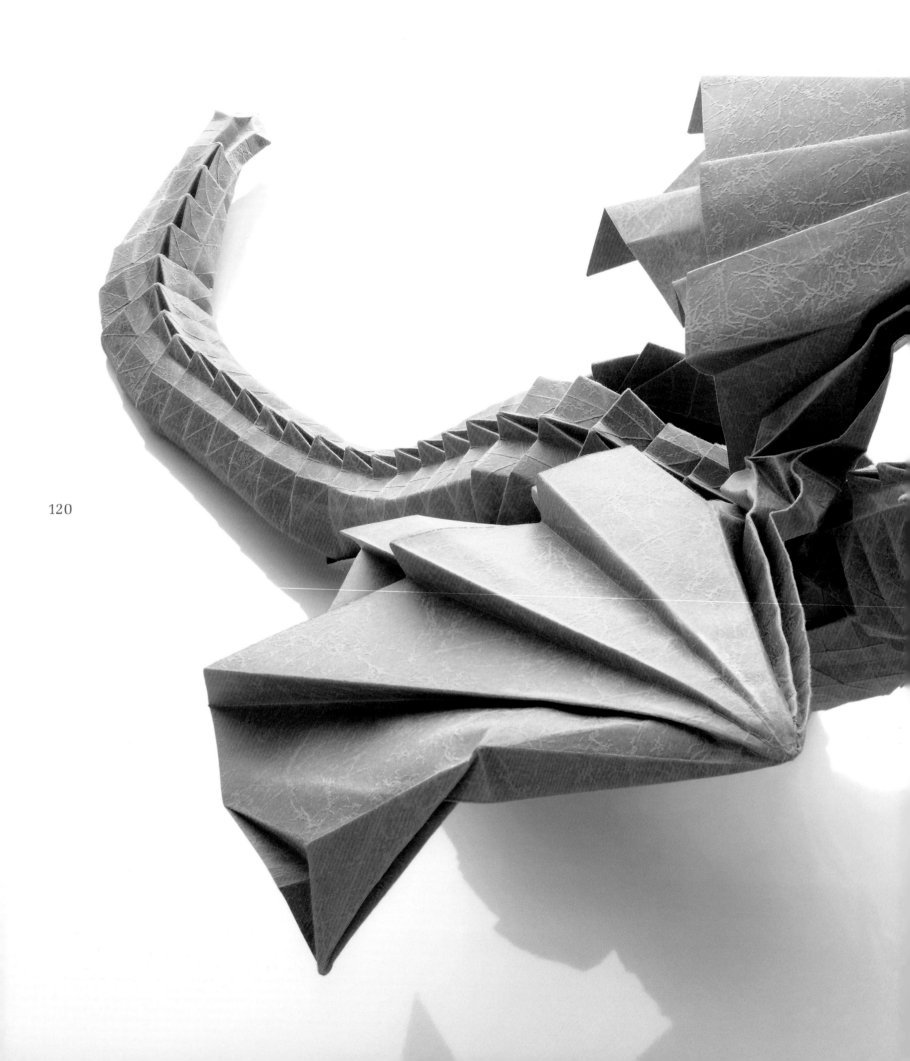

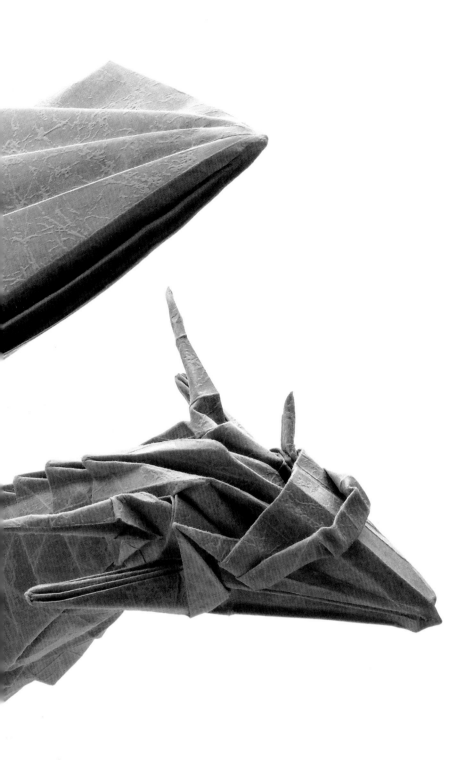

Joseph Wu, Vancouver, Canada

Joseph Wu has been constructing origami models
for thirty-one years. By the age of eleven, he was creating
his own designs. His website www.origami.as is a central
forum for origami artists all over the world.

"Ancient Wyrm," November 20, 2002

Wyrm is an archaic expression for dragon. In the
famous role-playing game Dungeons & Dragon, the wyrm
is a very old dragon of huge size and enormous power.

Satoshi Kamiya, Tokyo, Japan

"Temma 2005," May 2005

Folded from a square sheet of paper with a side lenth of
79 centimeters without the use of scissors or adhesive.

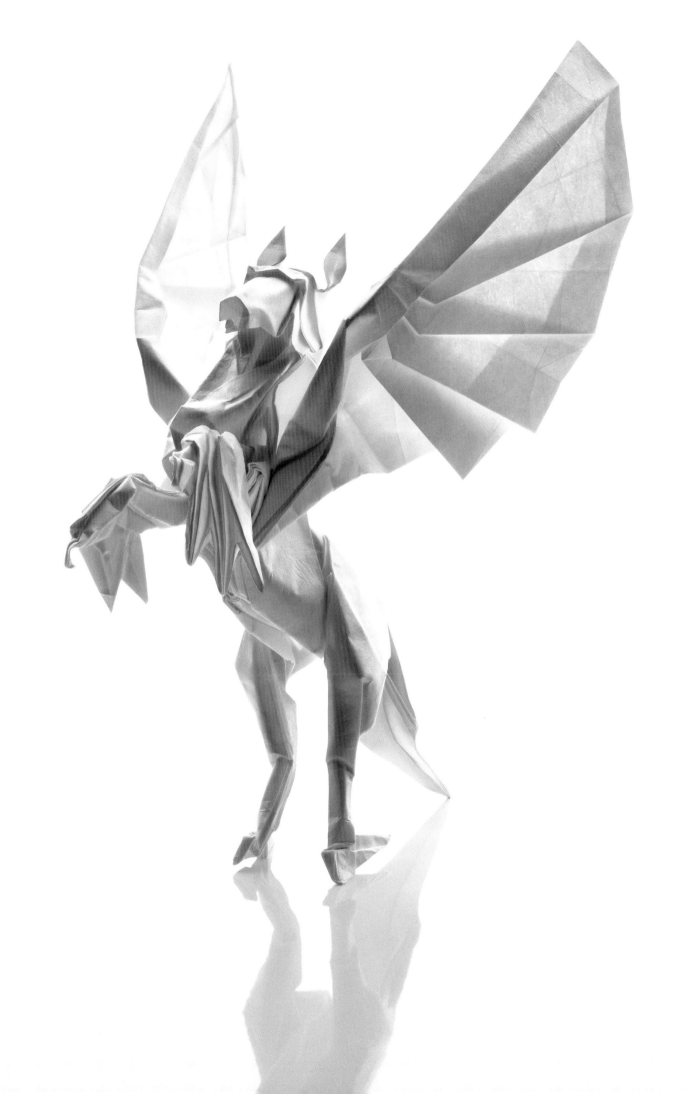

Ian Harrison, Cheshire, UK

Ian Harrison has been folding paper models since the
fifties and is currently a member of the British Origami
Society. In the nineties, he began to employ modular
origami as a tool in assisting mathematics students
with the solution of geometry problems in
three-dimensional space.

"Truncated Octahedron," July 2004

Based on a truncated octahedron thsi models
is made from six A4-sized sheets of paper without
the use of scissors or adhesive.

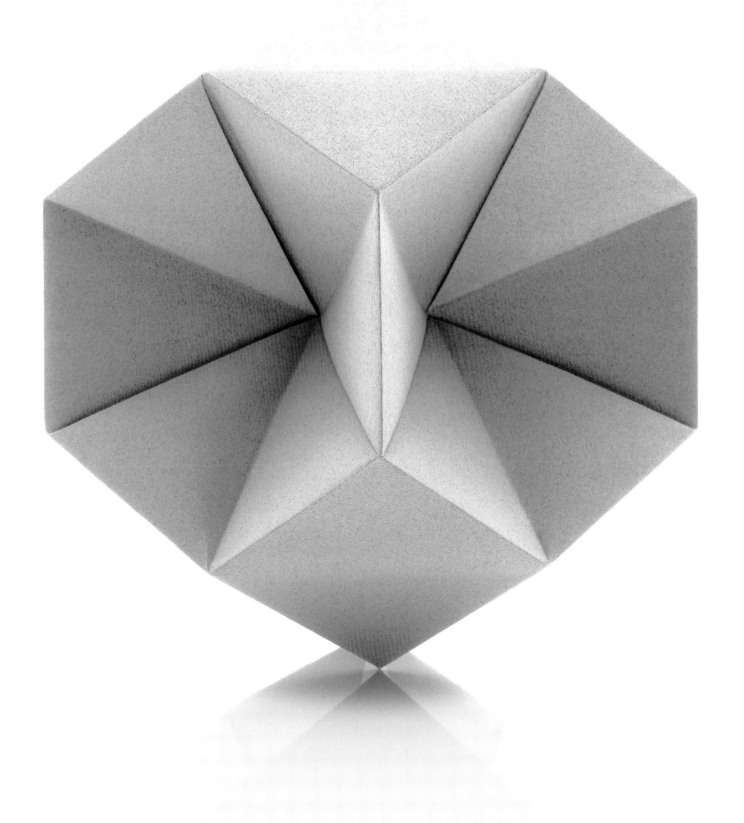

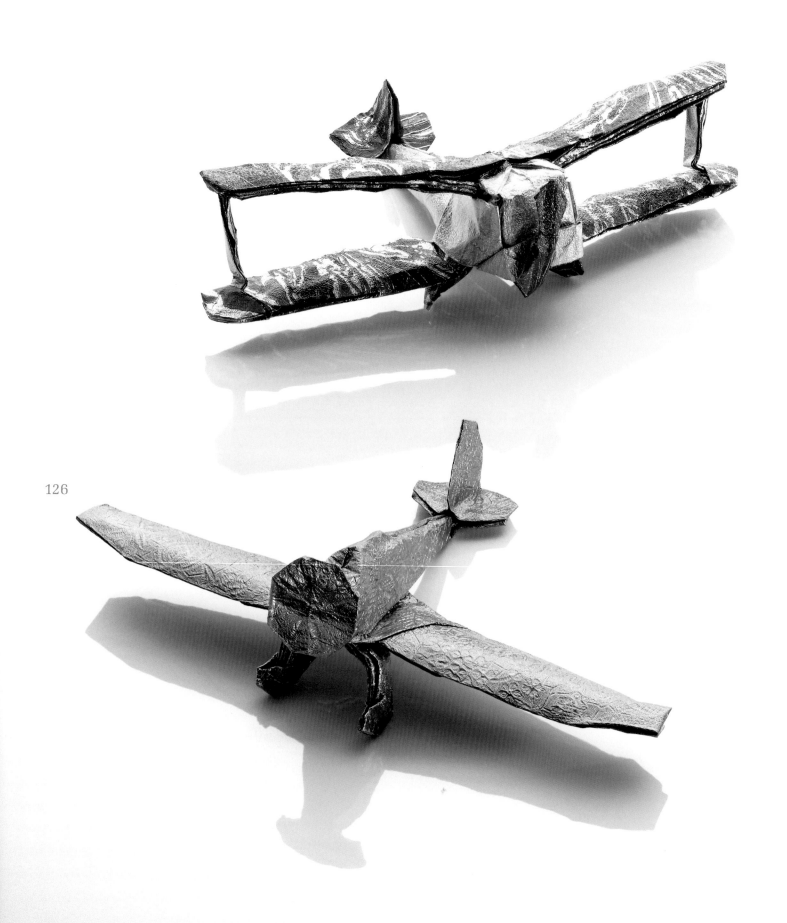

Peter Budai, Budapest, Hungary

Already at the age of nine Peter Budai began creating his own origami models. At the age of twelve, he published his first book entitled "Origami for Everyone." Peter Budai studied environmental engineering at the Technical University of Budapest.

"Monoplane," 1996, **"Biplane,"** 1997, **"Taking Flight,"** 1997

The models are folded out of one single sheet of paper in a traditional way without using scissors or adhesive. Their interesting surface structure results from the use of very thin paper used in flower shops for packaging.

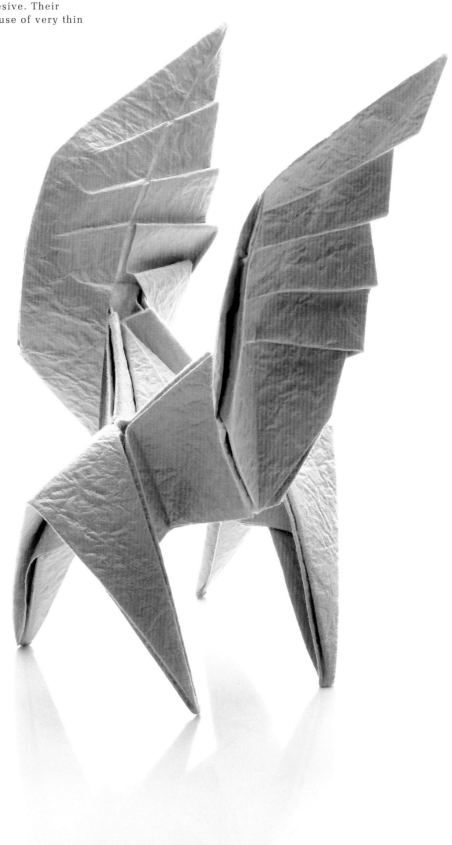

Stephen Weiss, Miami Beach, USA

At the age of eight, Stephen Weiss began to fold
paper models. He has now been practicing origami
for about fifty years. In 1984 he published the book
"Wings + Things: Origami That Flies."

"Pegasus," 2003, **"Horse,"** 2000

Each of the two models was folded out a single uncut
piece of square paper, using neither scissors nor glue.

128

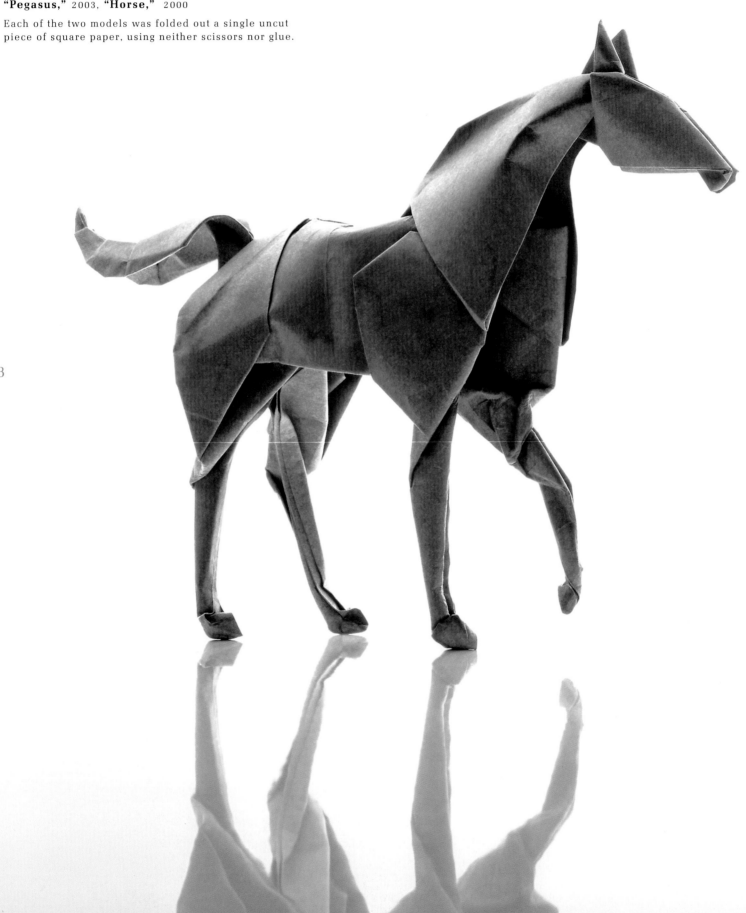

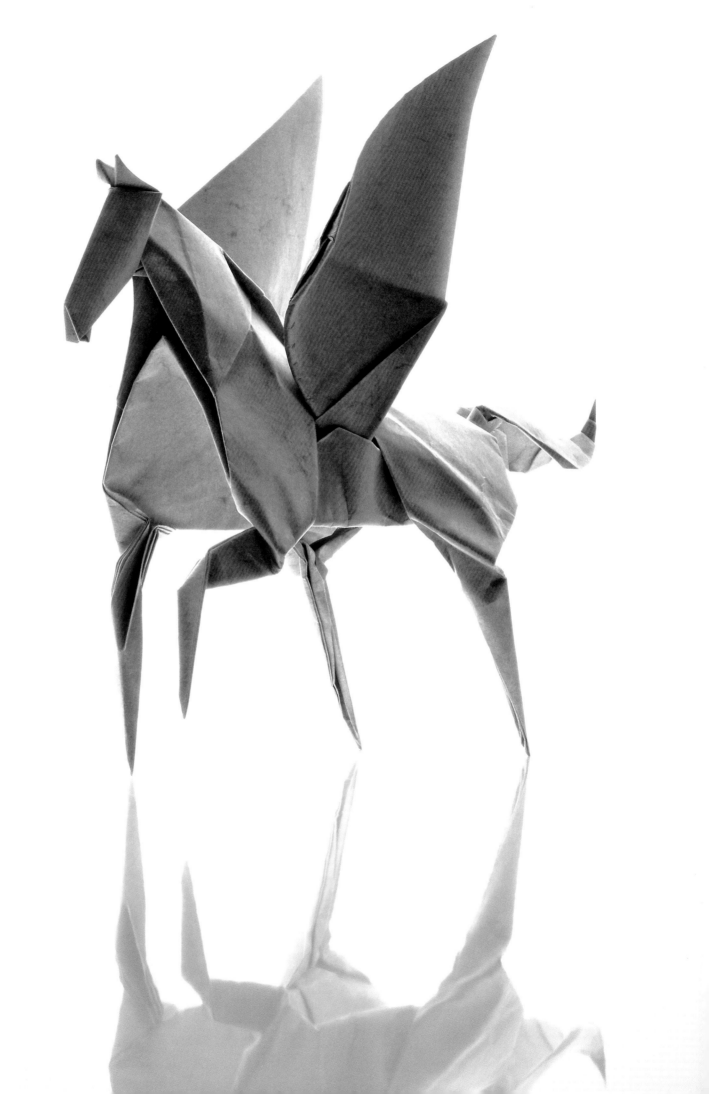

Vincent Floderer, St. Aulaire, France

Vincent Floderer is considered master of the "crumpling"
technique, in which the paper is extensively wrinkled and
crinkled before it is folded. Floderer's enthusiasm for the
diversity of biological forms is expressed in his stunningly
realistic models of aquatic animals and plant life.

"Aïe," 2000

The sea anemone on the rock counts 64 flaps and was
folded from a square 6-gram handkerchief/napkin
paper and subsequently colored. For the rock, paper
from the "Papeteries de Gascogne" was used.

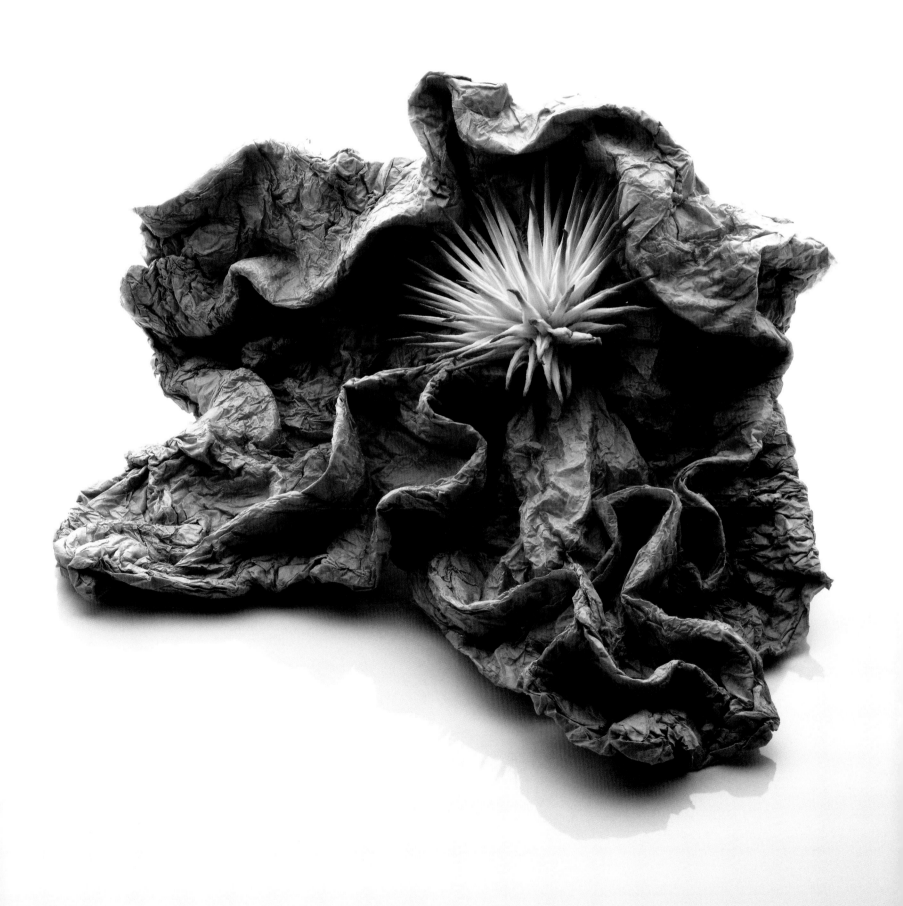

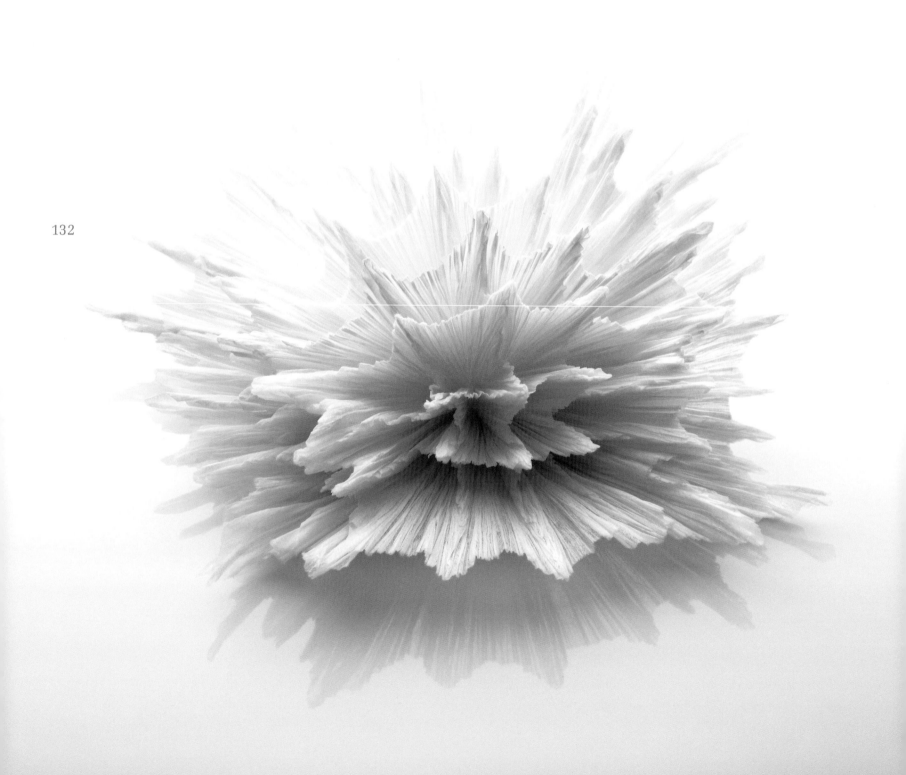

"À Mon Père," 1999

Folded from a square white handkerchief/napkin paper.

134

"Alios," 1999

Folded from paper from the "Papeteries de Gascogne"
and subsequently colored.

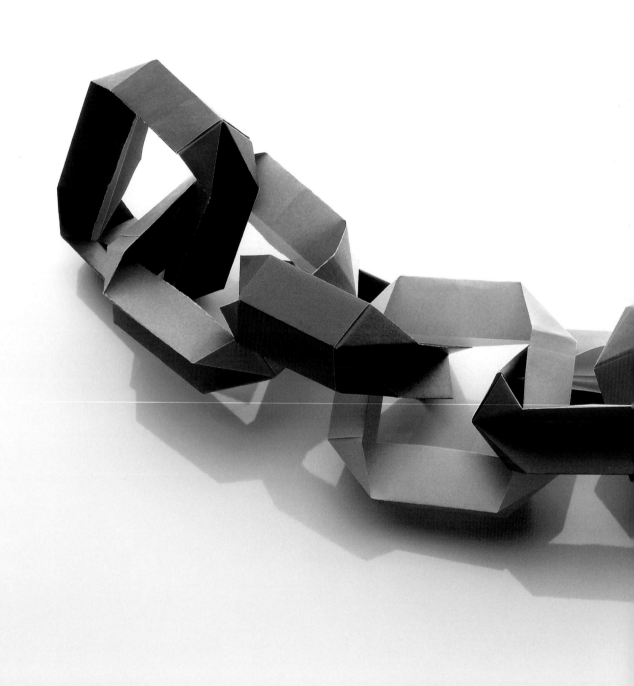

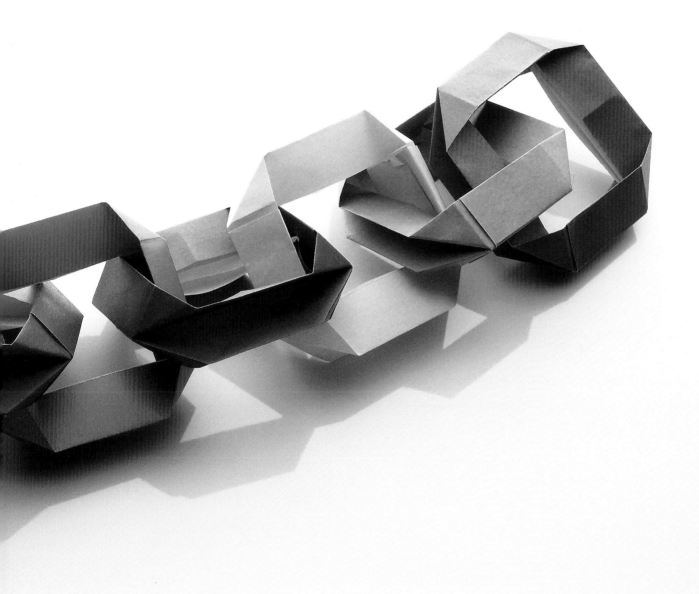

"Modular Chain"

Each of the ten many-cornered rings was folded by a member of the "Lillian Oppenheimer Wednesday Folding Group" to support "Masters of Origami." Lillian Oppenheimer founded the "Origami Center of America" in 1958, now Origami USA. Laura Kruskal developed the concept.

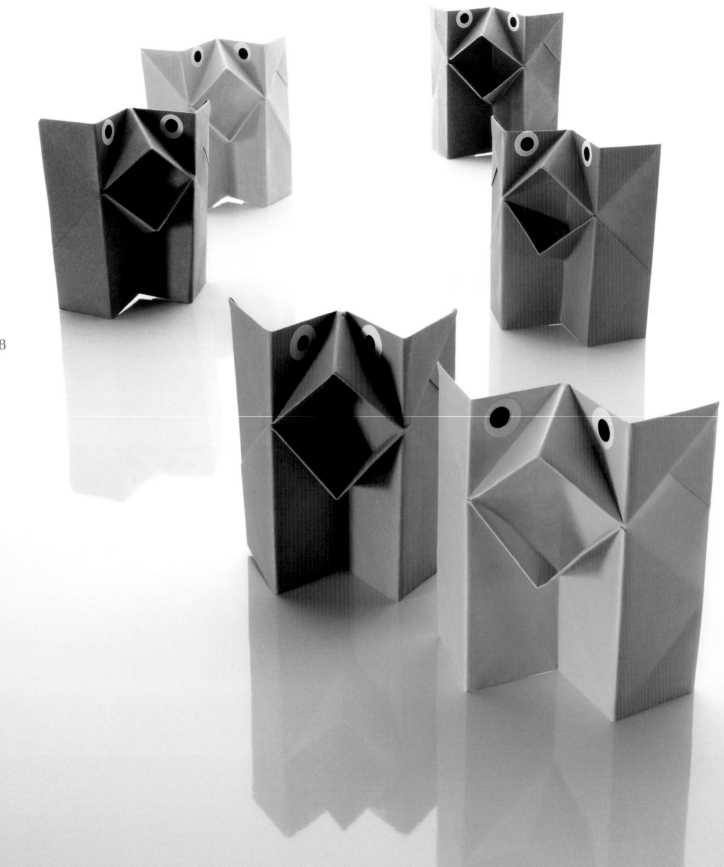

Laura Kruskal, USA

Laura Kruskal is an origami artist and the daughter-in-law of Lillian Oppenheimer who has made significant contributions to the promotion of origami in the West.

Noboru Miyajima, Tokyo, Japan

"Knight on Dragon," July 1996
Folded from a square sheet of paper
without the use of scissors or adhesive.

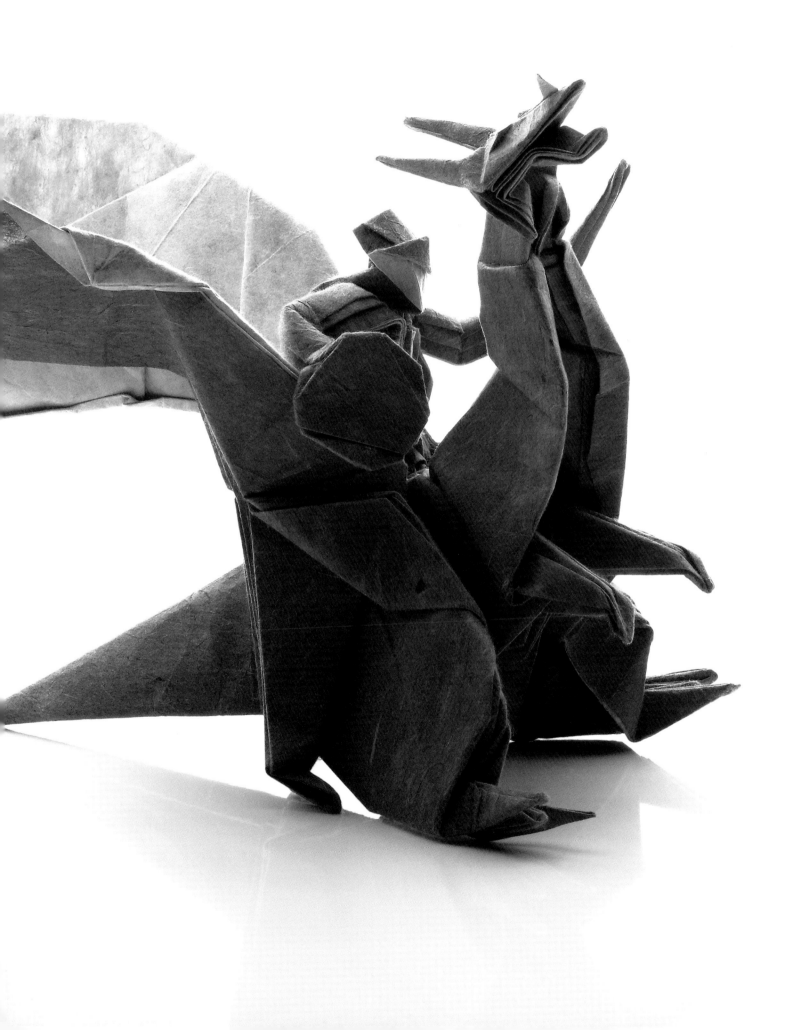

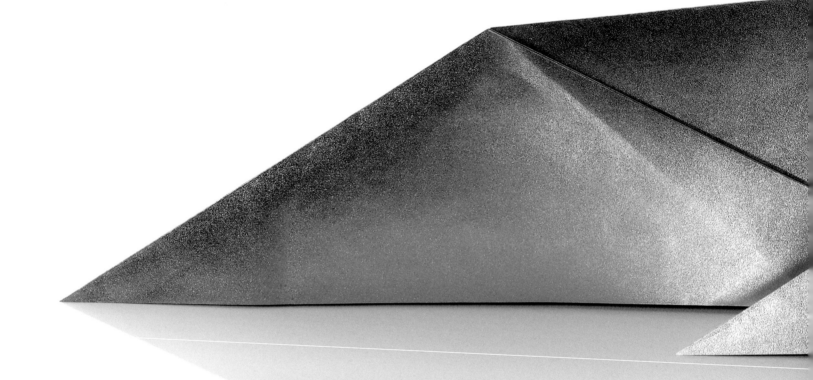

Noriko Nagata, Japan

Noriko Nagata studied mathematics at the Nara Women's University
and has been producing folded paper models for twenty-five years.
She has been a member of the Nippon Origami Association since 1992.

"Gnormon Of Wings," October 1994

The pattern of a logarithmic spiral in a square sheet of paper
constitutes the center of this wing sculpture in red and gold.

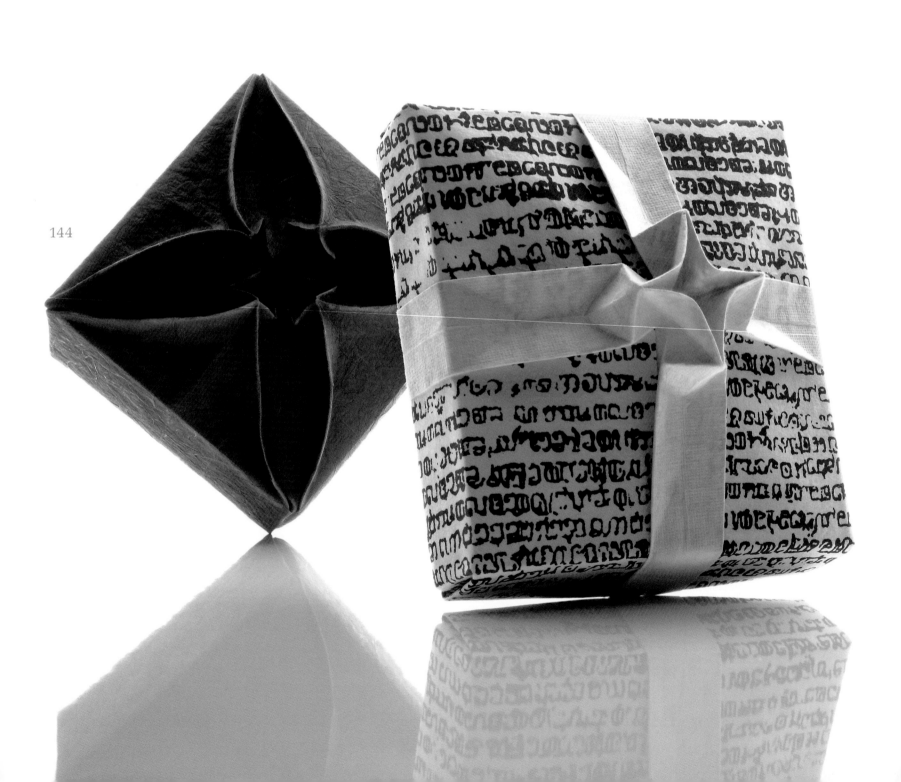

Arnold Tubis, Carlsbad, USA

Arnold Tubis taught physics at Purdue University in Indiana.
For forty years he has been creating origami models which
were inspired by mathematical problems. He published the
book "Unfolding Mathematics With Origami Boxes."

"Model Box Lids," April 2005

All three models were produced by folding uncut, square
sheets of paper containing a high percentage of cotton fiber.
Their simple symmetry is based on Euclidean geometry.

Peter Paul Forcher, Lienz, Austria

Peter Paul Forcher was born in Oberdrum
in East Tyrol in 1946. He has been active in
origami since 1982. He taught mathematics
at the commercial academy in Lienz from
1972 to 2000.

"Bird," 1996

The bird was folded from origami paper
and held together with double-sided tape.

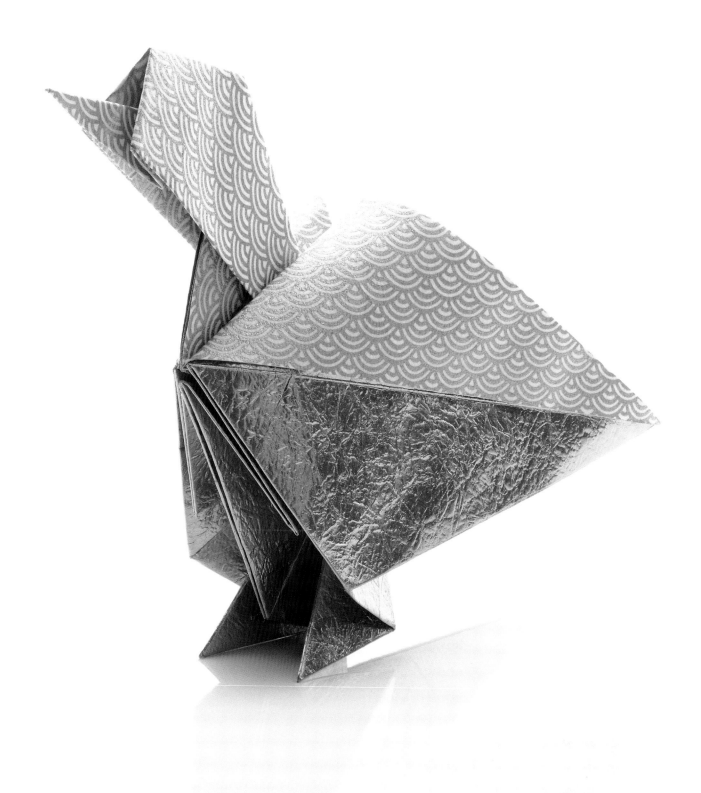

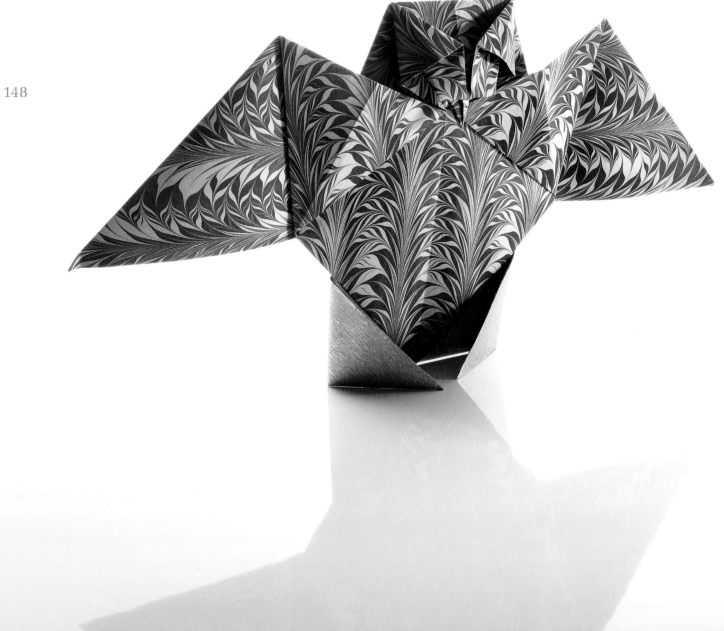

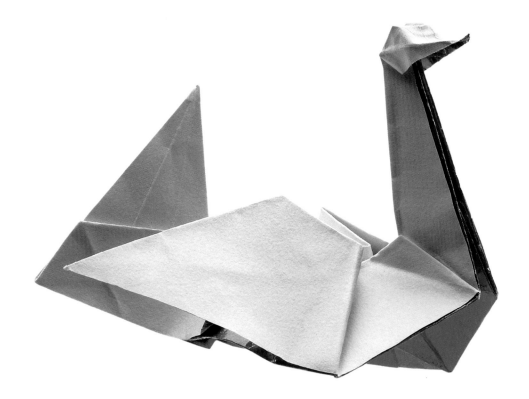

Herman Van Goubergen, Antwerpen, Belgium

Herman van Goubergen has been folding paper models for
thirty years. He lives as an origami artist in Belgium.

"On The Water, Under Water," 1995

The models symbolize the transformation from fish to bird
and were folded from a blue, metal foil.

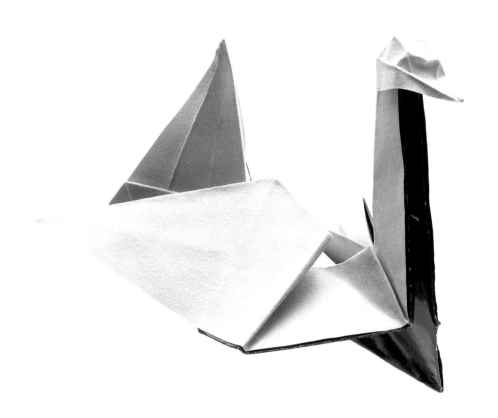

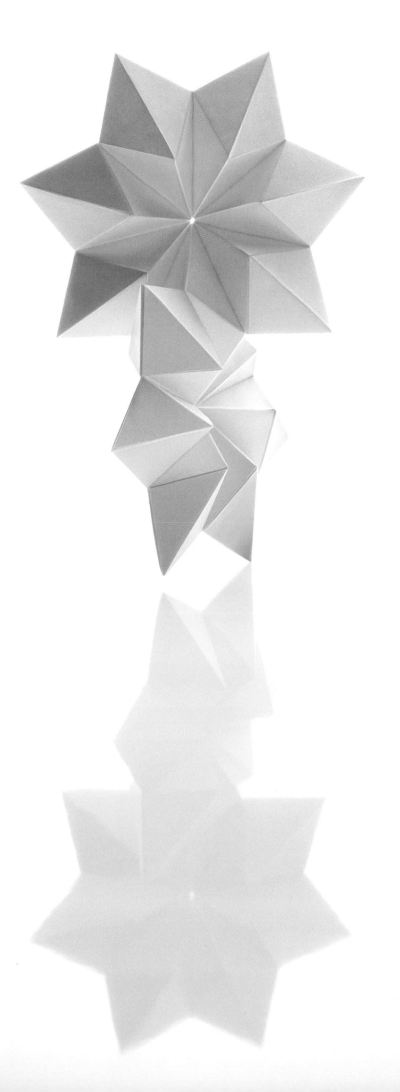

Wilhelm Möller, Mittweider, Germany

Wilhelm Möller taught electronics at the Mittweider Technical School.
He perfects the folding of paper strips since 1995.

"Peter & Annegret (Double Star)," 2003

Folded from strips of paper without the use of scissors or adhesive.
This folding technique is also called three-dimensional weaving.

Susumu Nakajima, Kyoto, Japan

Susumu Nakajima began folding cranes twenty-seven
years ago and now teaches origami in Tokyo.

"Bulls," May 2005

The models were folded from metal foil, Kent paper, and
sketch paper. Front and back faces of the models were
glued together.

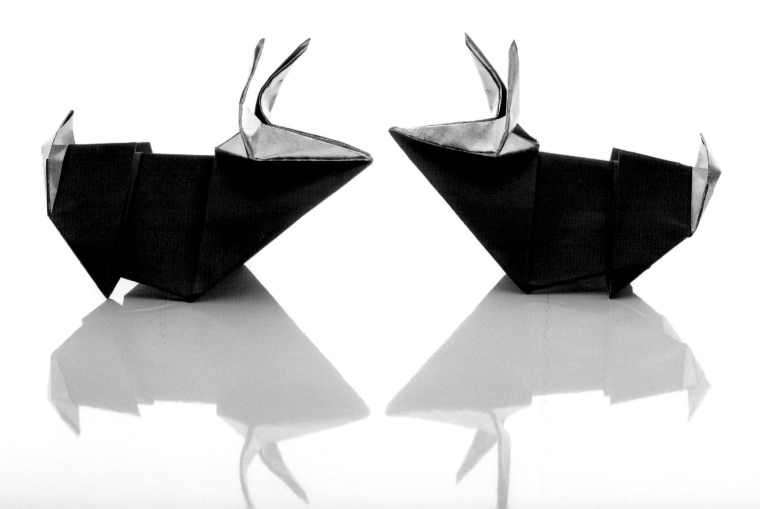

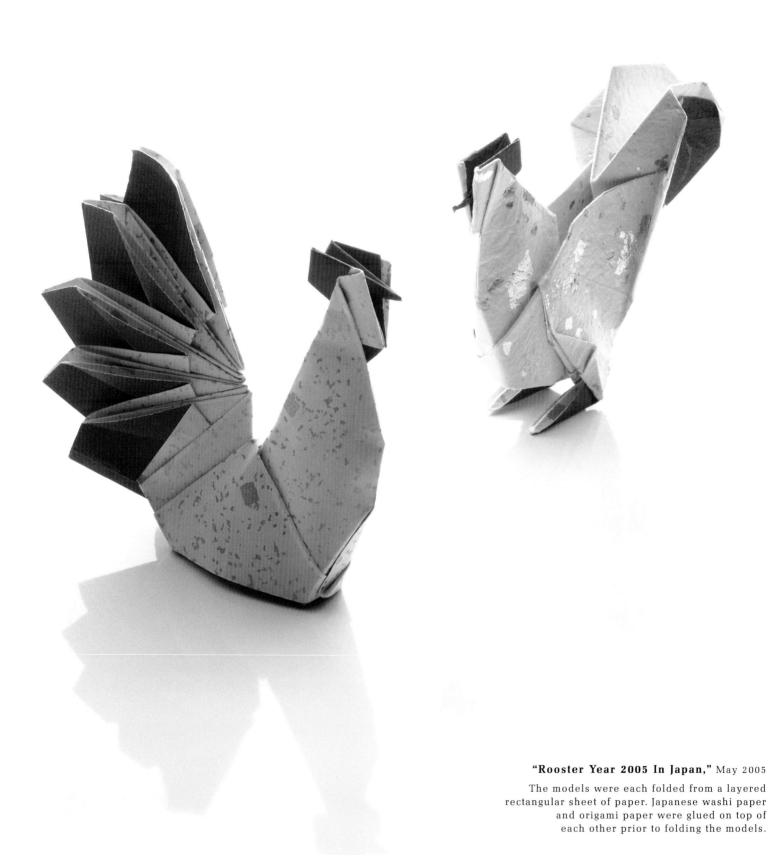

"Rooster Year 2005 In Japan," May 2005

The models were each folded from a layered
rectangular sheet of paper. Japanese washi paper
and origami paper were glued on top of
each other prior to folding the models.

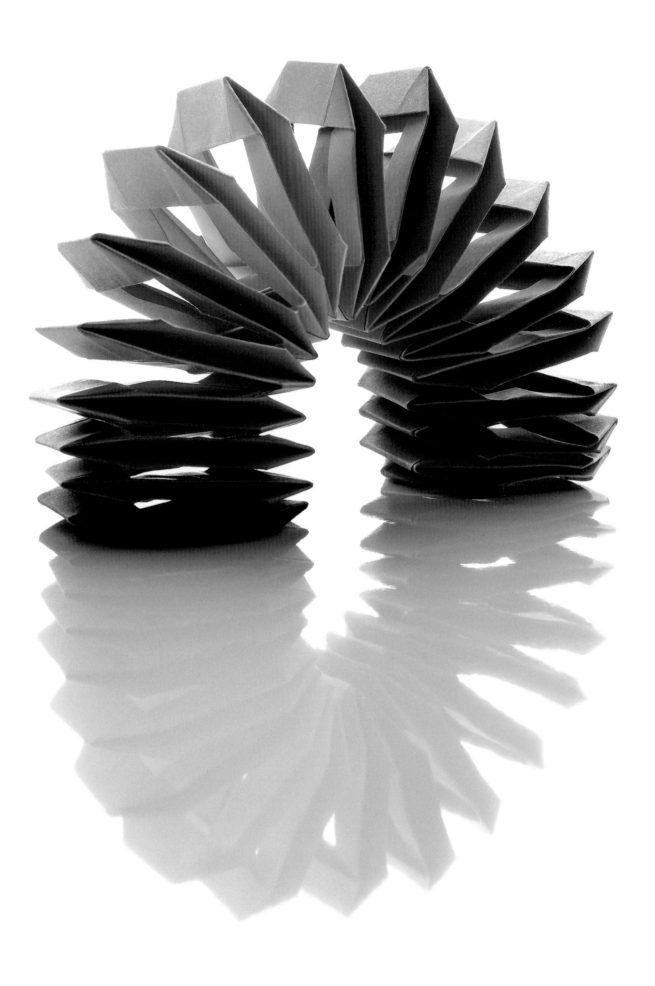

Gay Merrill Gross, New York, USA

Gay Merrill Gross folded her first paper models when she was nine. She has practiced origami for forty-three years and is an active member of Origami USA.

"Spiral Spring," 1998

A spiral concatenation of Laura Kruskal's many-cornered "Chain Units." Thirty-four rectangular pieces of paper were folded together without the use of scissors or adhesive.

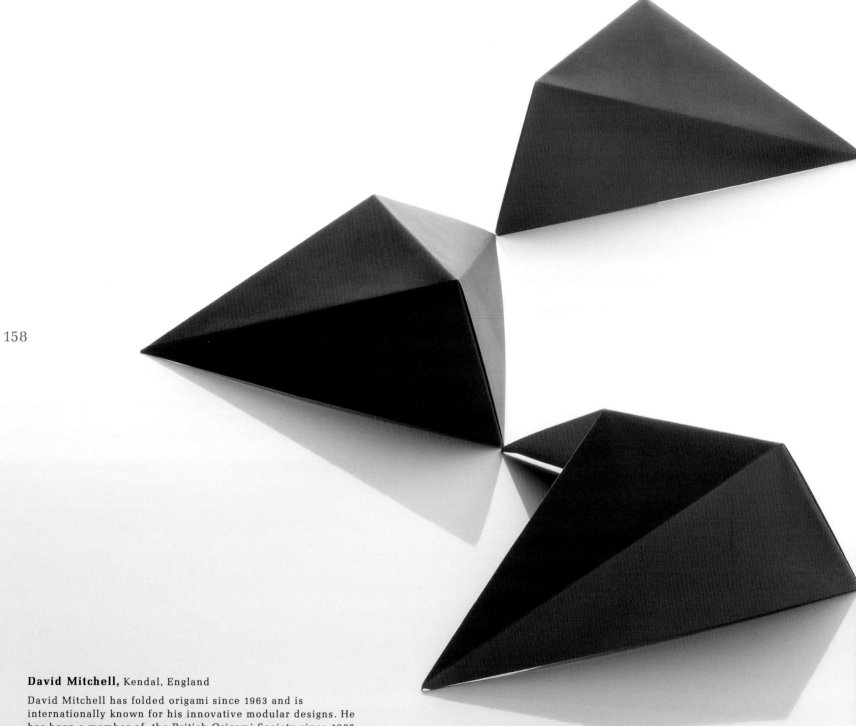

 158

David Mitchell, Kendal, England

David Mitchell has folded origami since 1963 and is
internationally known for his innovative modular designs. He
has been a member of the British Origami Society since 1987.

"Floor Sculpture," 1997

The sculptures follow the natural geometry of A4 paper,
a shape known to paperfolders as "silver rectangle." It was
constructed without the use of scissors or adhesive.

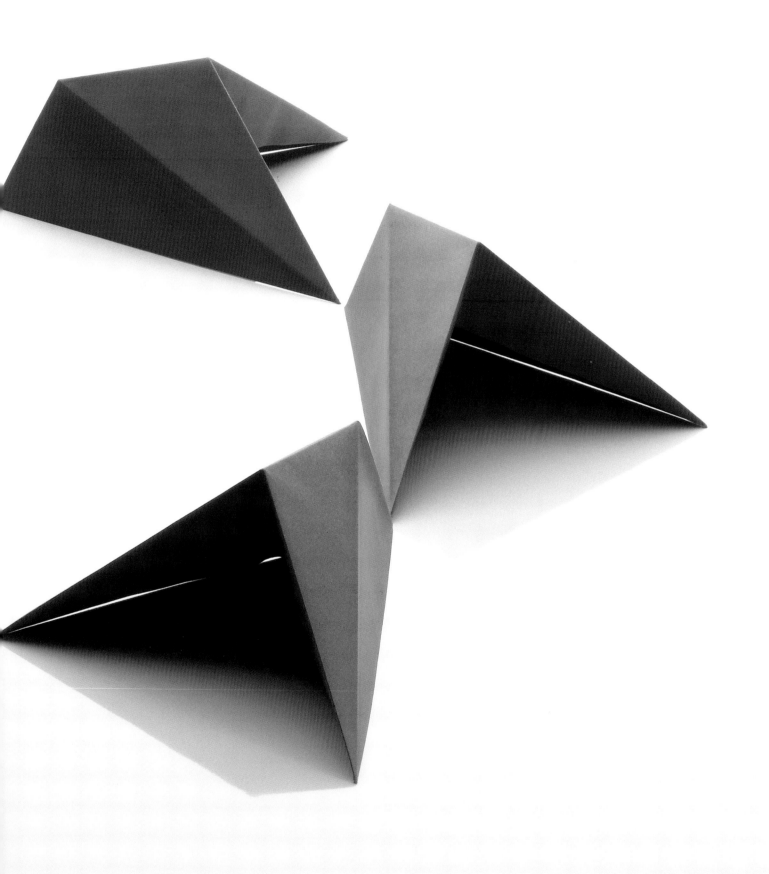

Jason Ku, Atlanta, USA

Jason Ku, eighteen years old, is one of the youngest, internationally renowned origami masters. Influenced by Robert Lang and John Montroll, he began developing his own paper models five years ago. This fall he will begin his studies at the Massachusetts Institute of Technology (MIT).

"Flying Bull," January 18, 2005

The bull was created out of red Korean Hanji paper. A square sheet with a side length of 60 centimeter was folded in wet-folding-technique and treated with a methyl-cellulose solution.

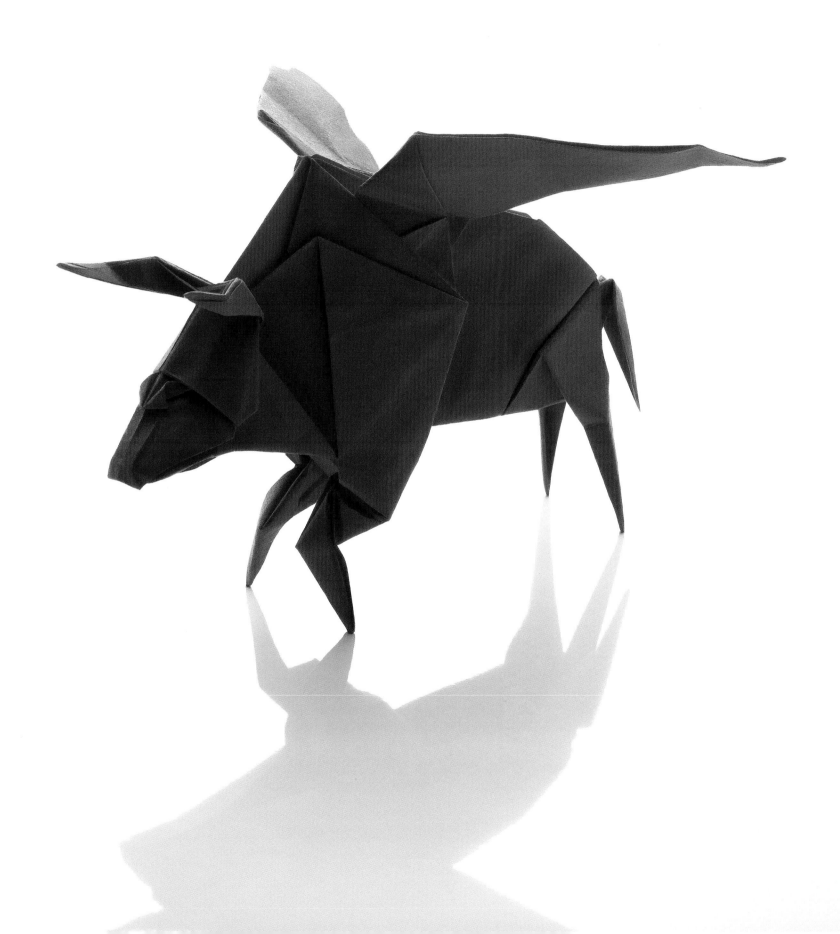

Practical Information

Hangar-7 at Salzburg Airport is far more than just a spectacular home for unusual aircraft. The impressive steel-and-glass construction is a place where art, passion, technology, and refined living meet.

Location

Hangar-7, Salzburg Airport
Wilhelm-Spazier-Str. 7A
5020 Salzburg / Austria
Tel.: +43 / 6 62 / 21 97
office@hangar-7.com
www.hangar-7.com

Opening hours

Hangar-7 Exhibition Area	9:00 AM – 10:00 PM
Hangar-7 Aircraft Collection	9:00 AM – 10:00 PM
Ikarus Restaurant	lunch 12:00 PM – 2:00 PM, dinner 6:30 PM – 10:00 PM
	(For reservations +43 / 6 62 / 21 97 - 77, ikarus@hangar-7.com)
Carpe Diem Lounge	9:00 AM – 7:00 PM
Mayday Bar	5:30 PM – 3:00 AM
Threesixty Bar	upon request
	Open daily.

162

We would like to thank all origami folders for their enthusiasm and support – in particular V'Ann Cornelius: without her, neither the exhibition nor this publication would have been possible.

Furthermore, we extend our special thanks to June Sakamoto, Paul Jackson, Miri Golan, Robert Lang, Koshiro Hatori, Michael La Fosse, David Lister, David Brill and Paulo Mulatinho.

Impressum

This book was published on the occasion of the exhibition
"Masters of Origami" at Hangar-7 in Salzburg / Austria
from July to September 2005

Editor	Hangar-7, Salzburg
Concept and Creation	Tom Wallmann
Design	Doris Schwarzmann @ Ahead Media, Vienna
Art Direction	Markus Gold @ Ahead Media, Vienna
Introduction and Essays	V'Ann Cornelius, David Lister, Koshiro Hatori, Michael LaFosse, Robert Lang und Paul Jackson
Editing	Peter Seipel, Stefan Wagner @ Union Wagner
Translation	Union Wagner
Paper	Galaxi Supermat, 170 g/m^2
Printed by	Dr. Cantz'sche Druckerei, Ostfildern-Ruit
Binding	Conzella Verlagsbuchbinderei, Urban Meister GmbH, Aschheim-Dornach near Munich

© 2005 Hatje Cantz Verlag, Ostfildern-Ruit;
artists; photographers; and authors
© 2005 for the reproduced work by Jean-Claude Correia:
VG Bild-Kunst, Bonn; for all other reproduced works: the artists and Hangar-7

Published by

Hatje Cantz Verlag
Senefelderstrasse 12, 73760 Ostfildern-Ruit, Germany
Tel. +49 / 7 11 / 4 40 50, Fax +49 / 7 11 / 4 40 52 20
www.hatjecantz.com

Hatje Cantz books are available internationally at selected bookstores and
from the following distribution partners:

USA/North America – D.A.P., Distributed Art Publishers, New York,
www.artbook.com
France – Interart, Paris, interart.paris@wanadoo.fr
UK – Art Books International, London, sales@art-bks.com
Belgium – Exhibitions International, Leuven, www.exhibitionsinternational.be
Australia – Towerbooks, French Forest (Sydney), towerbks@zipworld.com.au

For Asia, Japan, South America, and Africa, as well as for general questions,
please contact Hatje Cantz directly at sales@hatjecantz.de, or visit our
homepage www.hatjecantz.com for further information.

ISBN 3-7757-1628-9

Printed in Germany

Cover	"Flying Bulls" by Tomoko Fuse / photograph by Staudinger + Franke
Frontispiece	"OVNI" Uforigami by Vincent Floderer

All Origami photographs by Staudinger + Franke

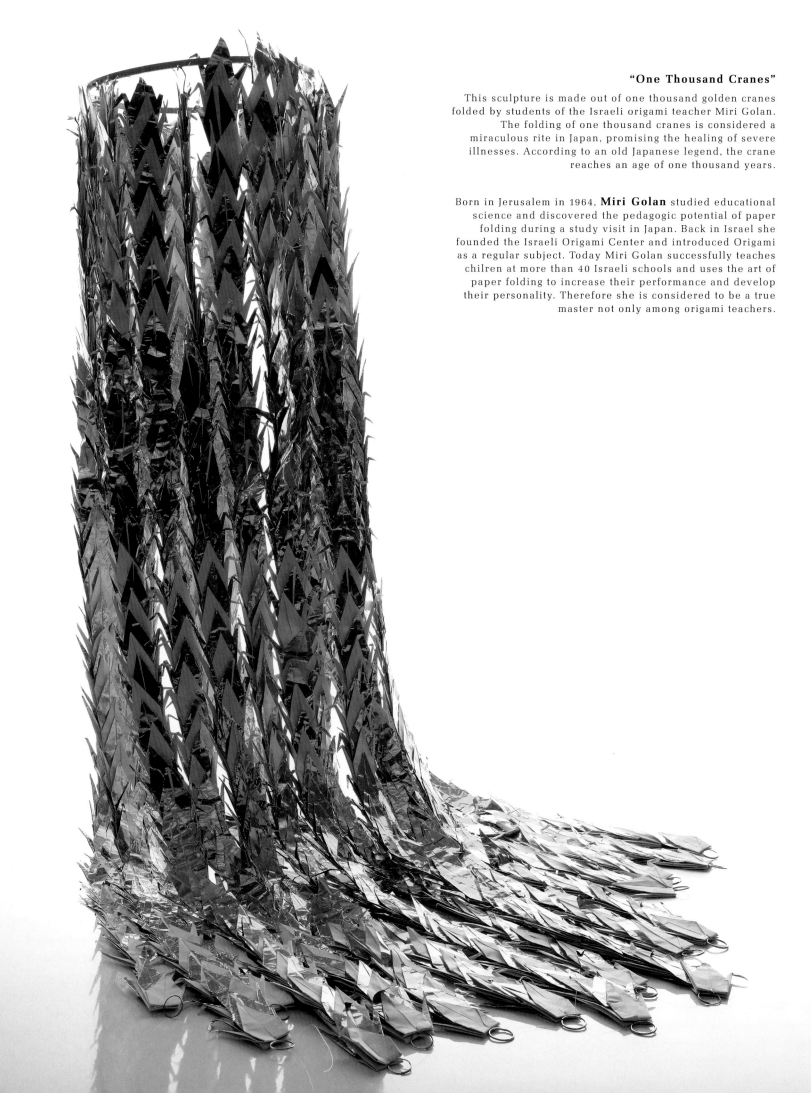

"One Thousand Cranes"

This sculpture is made out of one thousand golden cranes folded by students of the Israeli origami teacher Miri Golan. The folding of one thousand cranes is considered a miraculous rite in Japan, promising the healing of severe illnesses. According to an old Japanese legend, the crane reaches an age of one thousand years.

Born in Jerusalem in 1964, **Miri Golan** studied educational science and discovered the pedagogic potential of paper folding during a study visit in Japan. Back in Israel she founded the Israeli Origami Center and introduced Origami as a regular subject. Today Miri Golan successfully teaches chilren at more than 40 Israeli schools and uses the art of paper folding to increase their performance and develop their personality. Therefore she is considered to be a true master not only among origami teachers.